The JEFFERSON COUNTY EGAN MURDERS

The
JEFFERSON COUNTY
EGAN MURDERS

NIGHTMARE
on NEW YEAR'S EVE 1964

Dave Shampine & Daniel T. Boyer

Published by The History Press
Charleston, SC 29403
www.historypress.net

Copyright © 2014 by Dave Shampine and Daniel T. Boyer
All rights reserved

Images are courtesy of the *Watertown Daily Times* unless otherwise noted.

First published 2014

Manufactured in the United States

ISBN 978.1.62619.288.1

Library of Congress Cataloging-in-Publication Data

Shampine, Dave.
The Jefferson County Egan murders : nightmare on New Year's eve, 1964 / Dave Shampine, Daniel Boyer.
pages cm
ISBN 978-1-62619-288-1 (paperback)
1. Murder--New York (State)--Jefferson County--History--Case studies. 2. Murderers--New York (State)--Jefferson County--History--Case studies. I. Boyer, Daniel. II. Title.
HV6533.N5S528 2014
364.152'309747--dc23
2014032541

Notice: The information in this book is true and complete to the best of our knowledge. It is offered without guarantee on the part of the authors or The History Press. The authors and The History Press disclaim all liability in connection with the use of this book.

All rights reserved. No part of this book may be reproduced or transmitted in any form whatsoever without prior written permission from the publisher except in the case of brief quotations embodied in critical articles and reviews.

The authors dedicate this work in memory of

Ruth Boyer
1911–2012

Toby Donovan
1959–1989

Lucille Collier Shampine
1949–2012

CONTENTS

Preface 9
Acknowledgements 13

1. New Year's Eve Out of Hell 15
2. "Attracted to the Bad Boys" 25
3. "Law Enforcement in High Gear" 39
4. The Long Wait 57
5. Daughter: Pickett Lied 79

Epilogue 85
About the Authors 93

PREFACE

Just about everybody between the ages of 55 and 105 in New York's Jefferson County remembers New Year's Eve 1964. They might not remember where they were celebrating, or with whom they celebrated, but they most certainly remember the heinous events that took place on that cold, dark night fifty years ago. What happened at a desolate rest area sent shock waves throughout northern New York.

Not everybody was out partying and having a good time—especially not Peter Egan, twenty-seven; his pretty wife Barbara, twenty-four; and Peter's younger brother, Gerald, nineteen. They had planned on celebrating New Year's Eve later with friends at a local bowling alley, but first, they had some important business to attend to. Illegal business.

In the waning hours of 1964, the three were found dead, all with two bullets fired into their heads.

Even with their plans for the evening, the Egans and their associates had been starting to feel some heat. The Federal Bureau of Investigation had agents in Watertown, New York, working an auto theft investigation that reached all the way down the East Coast to Florida. A stolen vehicle had been found in a barn just outside Watertown, and Peter Egan was a suspect in the probe.

Might Peter start talking to the authorities and spill the beans on his accomplices about that and other crimes? He knew enough to put them all away in prison for several years.

As Peter and Barbara, the parents of three, and Gerald headed out on that fateful evening, it was business as usual for them. They were old pros

Preface

when it came to burglary and theft, and they were no strangers to police. It was likely no surprise to local authorities that in the new year of 1965, the 175 or so burglaries in Watertown was a significant drop from about 400 the previous year, when the Egans were up to their shenanigans.

They were brazen, hardcore thieves—brazen enough to steal from their partners in crime. There is no honor among thieves, and that, it appears, was their downfall.

On the last afternoon of their lives, the Egan brothers met with some of their friends, including a Watertown man, Joe Leone. They plotted a liquor truck heist—or so the brothers believed. None of the people involved in that night's events had jobs at the time. The Egans had been on the county's public assistance rolls for some time, and Leone was a laid-off trucker.

I had a very revealing two-hour conversation during the spring of 2013 with another party to the New Year's Eve plot, James Pickett. He was actually the first person to be arrested in the triple murder investigation—three years and a couple months after the event—and he, turning state's witness, provided information that helped police charge three more people: Leone, Willard Belcher and Belcher's wife, Bertha. A warrant against Willard was never served, however.

Pickett told me that after the case was closed, he never again talked to anybody about the Egan murders until we had our conversation early in 2013. He had kept it bottled up for nearly forty-nine years. When I asked him why he was talking to me, he replied that I was the only person who ever asked. He told me that he was an old, broken-down man, and he felt it was time to set the record straight before he died. Pickett said it was like therapy getting it all off his chest.

He died on April 15, 2013, a few weeks after our conversation. The resident of Limerick, New York, was eighty-one.

Unfortunately, as the reader will discover in the pages that follow, I eventually learned from a surprise source that Pickett might not have been as forthright with me as he had sounded. Perhaps that is why he said he could tell me things that nobody else knew, but he was afraid his phone might be tapped.

After the triple murder, nobody in the North Country felt safe anymore. The repercussions were felt for miles, even in my hometown of Redwood, thirty miles to the north. The killings changed the way people thought. I had never even heard the word "murder" until then. The only people I had ever heard of being shot were Presidents Lincoln and Kennedy. I was six years old at the time, in the first grade, and I can remember being petrified. Everybody was.

Preface

Rumors ran rampant. "It was a Mafia hit" was the most popular thought.

I always kept my ears and eyes open, listening to people speculating and gossiping about the Egans and about who might have had a reason to kill them. Peter, Barbara and Gerald had become folk legends in northern New York.

A few months after the murders, my father, William Boyer, took the family for a Sunday drive, which included a stop at the infamous rest area. This, he told us, was where the Egans were murdered. He pointed to some bullet holes in a metal trashcan. I freaked out and started to cry. I wanted to get the hell away from there. I didn't want to get shot in the head.

Around this time, my cousin Toby Donovan and I invented a game we called the "Egans' Game." We would get in Uncle John's car and slump over in the front seat, pretending to be Peter and Gerald Egan. We had become infatuated with the killings.

Then, in the summer of 1967, the case got a little close to home for me. My friend Dean Heath and I became acquainted with the Wonder Bread man. It started out one day when Dean told me that the delivery truck drivers were supposed to give free samples if requested. We saw the Wonder Bread truck roll into town and pull up to Lloyd's Grocery. We approached the driver and asked, "Mister, do you have any free samples?"

He handed us a whole box of jelly doughnuts, along with a big smile.

The next week, the truck was in Redwood again. The driver was the same tall, lanky man with thinning black hair who had been so nice to us before. We ran over, and this time he gave us a box of chocolate éclairs. We were hooked. It became a weekly ritual for more than a year. We never had to ask for samples again. Toby and I would be playing the Egans' Game in his dad's car, and then we'd run up an alley to the store and bum free doughnuts from our friend Joe the doughnut man.

Major news broke in March 1968. Three people, all from the Watertown area, were charged in the Egan case. The names meant nothing to me, but when doughnut day arrived, Joe the doughnut man didn't show up. A new driver showed up, and he wouldn't give me the time of day. I was crushed.

I asked Nancy Lloyd, whose parents owned the grocery store, what happened to Joe, and that's when I learned that my friend Joe was Joe Leone, one of the people jailed in connection with the Egan shootings.

I was shocked. For years, the thought of the Egans' killings scared me, although I had made a game of the event, and here was one of the alleged killers treating me every week. I had already decided that Joe was the nicest adult I had ever met. Joe liked watching our faces light up. He seemed to be a very nice, friendly, generous man.

Preface

Over the years, I continued to follow the case. I researched it and was drawn to the byline of James Brett, who had covered the Egan case for the *Watertown Daily Times*. When I telephoned him, I found him to be extremely helpful; he even gave me information he said he couldn't have printed in the newspaper.

Mr. Brett said he personally knew all three Egans, Leone, Pickett and the Belchers. In fact, he considered Leone a good friend.

"Joe was a real nice, quiet guy," he said. "But nice quiet guys can kill you, too." Some of what he told me was later confirmed by Pickett.

I began telling my story on Facebook, and in just a couple months, more than eight thousand people had viewed my account. A few of them were relatives of the alleged killers. They came forward and befriended me. Their curiosity prompted them to reach out. They wanted to know what happened on that cold night fifty years ago.

I knew I was sitting on a big story, but I also realized that I know absolutely nothing about writing a book or how to get it published. Recently, my friend Julie Stevenson sent me a copy of the book *The North Country Murder of Irene Izak: Stained by Her Blood*, written by Dave Shampine. I knew of him from his reporting with the *Watertown Times*. After reading the Izak book, I called him at the *Times* and told him about the treasure-trove of information I had collected. I was surprised that he didn't hang up on me. Indeed, he told me there was somebody else who was urging him to do a book about the Egan case. So it went from there.

And now, here's the rest of the story.

Daniel T. Boyer
Bowling Green, Kentucky

ACKNOWLEDGEMENTS

Putting together a story about the lives, activities and deaths of Peter, Gerald and Barbara Egan, as well as those people associated with the Egan family, was a task accomplished through the assistance of many people. The authors wish to express their sincere appreciation to all of those who willingly aided with research or were forthcoming in interviews.

Heading our list is John B. Johnson Jr., chairman of the board of the Johnson Newspaper Corporation, for providing full access to *Watertown Daily Times* staff, files and photographic materials.

Valuable research assistance was provided by *Watertown Daily Times* librarian Lisa Carr, Jefferson County historian James Ranger, Flower Memorial Library reference librarian Yvonne Reff and Erin E. Scott, records room supervisor at the New York State Court of Claims.

Research assistance was also provided by *Watertown Daily Times* reporter and assistant city editor Brian Kelly, Katie Stitely at The History Press and Mary Bryant of Henderson, New York.

The guidance of our commissioning editor at The History Press, Whitney Tarella Landis, was crucial in completing this effort.

William and Noreen Boyer provided technical assistance.

Key sources through interviews were Kay Hutchins-Vargas, JoAnn Pickett (married name withheld), Raymond Polett, Lawrence Corbett, Joseph Amedeo, Sharon Prosser Hook-Pfunter and James C. Brett. Other contributors in the form of interviews included Debi Kimball, Linda Mandigo, Patricia Turcott, Donna Johnson, Tony Leone, Gary Belcher, Phil

Acknowledgements

Nulty, Norm Horner, Joseph Coleman Jr., Shirley Coleman, Amanda Cole, Carla Welser, Yvonne Murphy, Jackie Spriggs, Del Leween Jr., Bud and Martha Prior Davis, Cathy Pippin, Wayne Titsworth and Noreen Frances Boyer Jr.

Also interviewed were Barbara Vout Egan's high school class of 1958 classmates Donna Stoodley Irwin, Lois Tuell Maxwell, Carolyn Wright Miller, Floyd Rivers, Louise Burt Kelly, Elaine Heath Greico, Doug Wilson and Sandra Stinson Reese.

A salute goes to Barbara M. Butler, whose encouragement helped us meet our deadline.

Resource material included *Murder & Mayhem in Jefferson County*, published by The History Press and authored by Cheri L. Farnsworth; trial coverage in the *Watertown Daily Times* by Robert Spath; the *Syracuse Post Standard*; the Charleston, South Carolina *Post and Courier*; and old newspaper stories found at Newspapers.com.

Other contributors by various means are Nicole Caldwell, executive director of Better Farm, an education center and artists' colony in Redwood; Paul Wimmer; Vintagequeen54 Videos; the Redwood Historical Society; the Redwood Tavern; the Redwood Fire Department; Chris Williams, using the name Johnny Truesdell at Abay.com; Susan Smith at *1000 Island Life* magazine; James and Steven Barker at the Facebook site "You Haven't Lived in Watertown, N.Y. If"; and the Facebook site "Where in the Heck Is Redwood, New York?"

Chapter 1
NEW YEAR'S EVE OUT OF HELL

Bill and Beverly Jay had been on the road for three or more hours, anticipating a New Year's Eve gathering with family and friends in Norwood, New York, when Bill pulled into a rest area for a nature call. Never again would Beverly consent to her husband stopping in a desolate location in the darkness of night to attend to a personal need. What the couple—he at thirty-nine and she at thirty-four—stumbled upon that cold evening of Thursday, December 31, 1964, was a scene of bloody, cruel inhumanity.

The two, who for about a year had been residents of Rochester, New York, were returning to where they had lived for most of their seventeen years of marriage. Awaiting them were their son, Terry, seventeen, and two daughters Bonnie, fourteen, and Sharon, thirteen, who had been sent ahead a week earlier to stay with their grandmother Hattie LaPoint in Norwood, a small community near the college town of Potsdam in New York's St. Lawrence County.

Bill, formerly a paper mill worker in Norwood and more recently employed in a Rochester packaging plant, was heading north on the new and unfinished Interstate 81 when, just a couple miles north of Watertown, New York, and about seventy-two miles from his final destination, he decided he needed to stop at the rest area he saw up ahead. He pulled onto the rest area's paved access road shortly before 9:20 p.m., according to state police reports at the time, and stopped a short distance behind a blue 1955 Mercury station wagon that was parked without lights at the edge of the roadway.

The Jefferson County Egan Murders

Leaving his headlights on, with Beverly remaining in their car, comfortably protected from the ten- to fifteen-degree temperatures outside, Bill exited and started his walk to a slightly snow-covered grassy area. As he glanced toward the station wagon, located about fifty yards from the highway, Bill noticed something in the snow at the auto's passenger side. Perhaps somebody was sick, he thought. He approached and found the lifeless body of a woman lying facedown in the grass, resting perpendicular to the car. Her head was about a foot and a half from the vehicle. Bill started to reach down to her but stopped abruptly when he spotted a large patch of blood around the woman's head.

Stunned by his discovery, Bill hustled around to the driver's side of the Mercury. The tightly closed windows were fogged over, so he couldn't see inside. He opened the door to view two occupants in the front seat—two motionless men, seated upright. The action of the door's opening prompted the two figures to tilt to their right. There was still life in the car but not in the two men. A small dog, its fur matted crimson from the blood-soaked upper back of the front seat, was barking and excitedly jumping around.

Again, Bill refrained from touching the bodies. Instead, he closed the car door, rejoined his wife, hastily told her of the bloody massacre he had found and drove off, hoping to reach a telephone. That, they found, would be no easy task on New Year's Eve. No public phones were in sight as they traveled unfamiliar streets and roads, and businesses had closed early for the holiday. Frustration built as minutes turned into what seemed like hours.

After checking a diner, which also was closed, they came upon a farmhouse at the corner of Routes 11 and 342, a short distance north of the hamlet of Calcium. An outdoor light was on, so they stopped there. Shirley Coleman, at home with her children—ages eleven, nine, eight, five and two—greeted the strangers.

"They were scared to death," Mrs. Coleman recalled recently. "They were just shaking. I felt so bad for them. They told me they had found three bodies in a rest area on Route 81 and that a woman's body was on the ground. They could hardly talk they were so upset."

Mrs. Jay "was so scared that she held my youngest, Lucille, all the time they were here," which she said was up to about forty-five minutes.

Mrs. Coleman did not remember the time of this bizarre visit. It was dark outside, she said, but not too late because her children had not gone to bed. Aware that her husband, Joseph, would be returning home from the grocery store and that two house guests were soon to arrive, Mrs. Coleman said she had no qualms about letting the strangers cross the threshold of her home. She granted Mr. Jay the use of her telephone to call state police.

New Year's Eve Out of Hell

Joseph Coleman returned while Mr. Jay was on the phone.

Following a trooper's instructions, the couple bid farewell to their shocked hosts and drove south on Route 11 to the state police headquarters, located just north of the Watertown city limits.

"That was the last we ever saw of them," Mrs. Coleman said.

She admitted that the evening's startling development had left her frightened.

"I was afraid the murderers might be hiding in our barn," which was used for the storage of hay and machinery.

When the Colemans later heard a news report in which the victims were identified, they recognized one name. Barbara Ann Egan, twenty-four, was

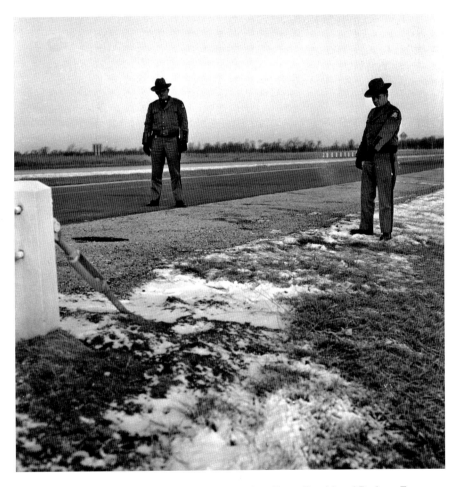

The Interstate 81 rest area north of Watertown, where Peter, Gerald and Barbara Egan were gunned down, is inspected by state troopers David G. Hall (left) and C. David Hudson for more evidence.

the daughter of Raymond C. Vout, a work colleague of Joseph Coleman at Northrop Motors, a Ford dealership on Arsenal Street in Watertown.

"We went to her calling hours," Mrs. Coleman said.

State trooper C. David Hudson was the first to arrive, followed by troopers Roland E. Ferguson and B.E. "Buddy" Boyer. Their confirmation to headquarters that they were at a major crime scene prompted a call to the home of Lieutenant Thomas E. Nulty, the Watertown zone state police commander, at Honeyville, south of Watertown and near Adams Center.

The lieutenant was hosting a small get-together to toast the passing of a year in which the escalating Vietnam conflict was becoming a growing concern. People were still in mourning over the assassination of President John F. Kennedy nearly fourteen months earlier, but 1964 had not really been such a bad year. Kennedy's goal of space travel was advanced in January when the unmanned Apollo craft attained Earth's orbit. The young British group The Beatles took the United States by storm with three appearances on *The Ed Sullivan Show*, the Ford Mustang was introduced, Martin Luther King Jr. was a Nobel Peace Prize winner and the St. Louis Cardinals made Missouri fans and New York Yankee haters happy by taking the World Series trophy. Nikita Khrushchev fell from power in the Soviet Union; Nelson Mandela was sentenced to life in prison in South Africa; and Lyndon B. Johnson, who had inherited the Kennedy presidency, won his own term, defeating Republican opponent Barry Goldwater.

Toasts to the New Year at the Nulty home, and at another residence, would have to be put off.

"My dad took the call, relayed the info to our guests and soon everybody was gone," recalled Phil Nulty on Facebook, himself to become a trooper years later. "I next saw my dad three or four days later."

The lieutenant and his wife were hosting a small party for their neighbors, Jefferson County sheriff's detective John J. Griffith, trooper Donald Hosley and their wives when the call to duty came.

Another call broke up a second party. Trooper Bill Boulio arrived at the Watertown troopers' headquarters about an hour early for his midnight shift, not knowing what had happened, and was immediately assigned desk duty to handle the telephone. He was instructed to call the home of trooper James McCarthy in Glen Park to inform all investigators and uniformed troopers to report for duty.

"They didn't believe me at first," Mr. Boulio recalled.

At the McCarthy house, "I remember the phone ringing and all the guests who were troopers quickly left," the hosts' daughter, Pamela McCarthy

New Year's Eve Out of Hell

DeMarco, said in a Facebook post on March 8, 2013. "Some of the wives stayed behind, and I remember hearing pieces of conversation about what little they were told before the guys left."

Troopers found the dead woman wearing Kelly green stretch pants, a darker green imitation suede coat with a turned-up collar and one snow boot. Her long brown hair was in curlers. Initial examination of the body revealed at least one bullet wound to the head.

The woman was not wearing underwear, police later revealed. This was common for her, a source said.

As one of the troopers opened a door to the station wagon, he found the dog, a Pekingese, crouched on top of the front seat's back rest, paws resting on the shoulder of one of the slumped-over victims. The little canine "displayed ferocity," the *Watertown Daily Times* reported, and had to be distracted before the officers could carry on with their investigation.

Both men were wearing dark winter jackets, sports shirts and trousers. The victim in the passenger seat was leaning across a padded wooden crutch that was to his side. The man was found to have a crude wooden leg strapped to the stump of his left thigh. His arms were outstretched, as if in a pleading gesture.

The trio—Mrs. Egan; her handicapped husband, Peter W. Egan Jr., twenty-seven; and his nineteen-year-old brother, Gerald F. Egan, who was in the driver's seat—appeared to have been the victims of a gangland-style execution. The victims were well known to police, particularly in Watertown, for their history of arrests.

Dr. William W. Hall Jr., a forty-six-year-old general practitioner who was in the eighteenth year of his Watertown practice, responded to the scene, serving as attending physician on behalf of District Attorney Angus G. Saunders, who was acting county coroner. Dr. Hall determined that all three victims had been shot twice in the backs of their heads. He concurred with the troopers' belief that the killer or killers were backseat passengers.

Bullet holes in the right lower corner of the windshield, as well as a chip in the rear-view mirror, possibly from a bullet fragment, supported their theory. Dr. Hall said the gun used to kill Peter Egan was held within inches of his head and suggested that the bullets passed through his head and into the windshield, an observation that would later be disputed in the continuing investigation.

The physician estimated that the weapon that killed Gerald Egan was about two or three feet from his head when fired.

Pathologist Richard S. Lee, who was to be appointed Jefferson County medical examiner in 1968, performed the autopsies. His findings were specified in eventual courtroom testimony.

The Jefferson County Egan Murders

Gerald Egan was shot once in the right temple, with a .25-caliber bullet passing through his brain and skull and becoming embedded in the flesh near his right eyebrow. A through-and-through wound in his right hand indicated a defensive action as the discharged projectile slammed into his temple. A second shot entered the back of his neck and exited out his left eye.

Two shots were fired from a .25-caliber weapon into Peter Egan's left ear. One of the small missiles exited from his right cheek, while the second crossed through his skull, exiting from his right ear. It appeared as if he had

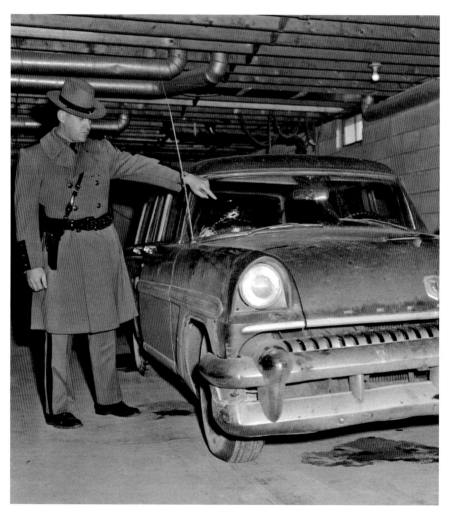

New York state trooper Daniel L. Sacco shows where bullets pierced the windshield in the Egan death car.

turned to look toward the backseat; hence, he likely saw the murder weapon pointed at him.

The bullet holes in the windshield were created by a .38-caliber gun, police determined. As Mrs. Egan was felled by a .38, police believed that she attempted to run, and three quick shots were fired at her from inside the car, missing their target.

Mrs. Egan's body showed signs of a struggle. She had multiple cuts and bruises, particularly on her right foot, left knee and lower back. Near her body were her hair curlers, two quarters, a dime, several pennies and S&H Green Stamps. A possible blow to the head with a blunt object might have caused a deep cut to the bone behind her right ear, resulting in the separation of the skull from the bridge of her nose. The gash left some brain tissue exposed.

Dr. Lee also found three fingernail punctures on her right wrist, leading to the assumption that her killer had grabbed her.

An investigator in the case, Raymond O. Polett, said that when Mrs. Egan fled from the car, her killer, "in hot pursuit," tackled her as she crossed the highway. The killer threw her down onto the icy-cold pavement, put his foot on the back of her neck and fired his gun. A .38-caliber discharge entered Barbara Egan's left ear and continued out her right ear, Dr. Lee determined. He described her second shooting as a contact wound on the top of her head. That bullet exited near her left ear.

The woman's limp body was then dragged from the roadway, leaving streaks of blood on the pavement, and was deserted at the location where Mr. Jay would make his grim discovery.

Dr. Hall estimated at the murder scene that the shootings occurred shortly before 9:00 p.m., although police came up with at least one witness who placed the station wagon at this location at about 7:45 p.m.

Two expended cartridge casings of a .25-caliber weapon were on the backseat floor, and two others were on the frozen ground in front of the car. Police later told reporters that the bullets had apparently been fired from an automatic, "rimless and nicked with ejector pin marks."

Robbery was not a motive. Barbara Egan's purse, containing cash, trading stamps, cosmetics, some unspent .38-caliber bullets and the car's registration certificate in her name, rested on the rear seat. Identification documents were found in the men's wallets, with fifteen dollars in Peter's wallet. On the front seat floor, troopers saw a six-pack of beer, with four full cans, and a six-pack of Coke, including one empty. An unused pair of work gloves, still stapled together, was on the rear seat floor.

Outside the car, to the left of the front bumper, were more hair curlers. Also located was the mate to the boot on the woman's foot.

Two guns were used that night, pointing to the possibility that there were two shooters. The brothers were "taken out" with a .25-caliber gun, while a .38-caliber weapon felled Mrs. Egan. In all, nine or ten shots were believed to have been fired, with three going through the windshield, police said. Perhaps a shot was fired through the windshield at Mrs. Egan as she frantically attempted to run.

The location of her body placed her out of the sight of passing motorists. But there would not have been much traffic on the highway anyway, since the still-under-construction road ended about two miles north of the rest area.

That small detail raised an interesting point: there seemed to be no logical reason for the Egans to have driven here. A possible consideration was that they were engaging in the international transport of narcotics, since the Canadian border was about thirty miles away, and were getting in somebody's way in the criminal trafficking.

Investigators could theorize that one or two of the killers either rode to the rest area with the Egans as backseat passengers or rendezvoused there with their targets. For motives, initial thoughts considered vengeance or that the Egans had to be silenced.

There had been little if any snowfall that final day of the year, so there were no remnants of a second vehicle's tire tracks.

Jefferson County's New Year's Eve massacre made headlines coast to coast as newspapers carried stories circulated by the Associated Press and United Press International: "Triple Murder Baffles," teased the *Hagerstown Morning Herald* in Maryland; "Triple Murder Probed in NY," announced the *Lubbock Avalanche Journal* in Texas; and "Found Fatally Shot," said the *Arizona Republic* in Phoenix.

Reports of the slayings were also found in the *Thomasville Times Enterprise*, Georgia; the *Charleston Daily Mail* in West Virginia; the *Tri-City Herald* in the state of Washington; and even in California, in the *San Bernardino County Sun*.

Meanwhile, police had one witness to the murders. Unfortunately, the witness—Queenie, as Barbara Egan called the little dog—couldn't talk. Troopers took the longhaired dog to their headquarters and later handed her over to a family member.

Any hope that Queenie might react excitedly in the presence of a suspect was lost two weeks later when she was struck and killed by a vehicle in front of the home of Mr. and Mrs. Clifford L. Shaw on Adams Road, in the town

New Year's Eve Out of Hell

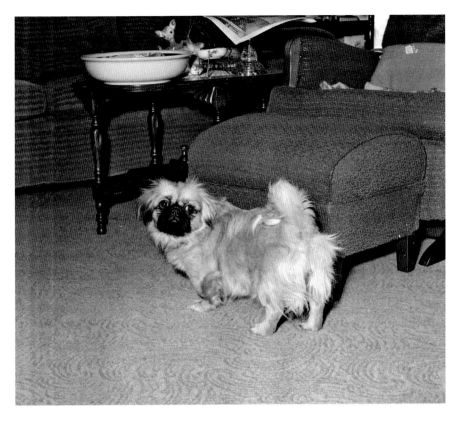

Queenie, the only survivor in the Egan triple homicide, was struck and killed by a car two weeks later.

of Watertown, outside the city limits. The Shaws had taken custody of the dog. Mrs. Shaw was an aunt of the Egan brothers.

While Watertown police and Jefferson County sheriff's deputies assisted state troopers in a ground search of the area for possible evidence, William and Beverly Jay were someplace where they could never have expected to spend the holiday. Long into the morning hours of New Year's Day, the couple endured the repeated questions of investigators. They were not suspects, but police not only needed to rule them out but also hoped to secure from them any possible clues hidden in the backs of their minds that might give some direction in the search for the executioners.

Their children—Terry, Bonnie and Sharon—had spent the night at the home of friends, across the road from Grandma LaPoint's home. When news broadcasts that first morning of 1965 disclosed the murders along the new interstate highway, the siblings' friends misunderstood what they heard.

Police had released the names of the couple who discovered the bloody scene, so Mr. and Mrs. Jay were named in the news reports. The youthful hosts rushed to tell their guests that their parents had been found dead along a roadside.

The three grief-stricken youths ran to their grandmother's house, where they were assured they had been given wrong information. Their mom and dad were fine and would be arriving soon.

Their eldest daughter, later Mrs. Bonnie Daniels, the last surviving member of the Jay family, recalls that her mother became paranoid and feared the killers were going to come after them. State police actually shared her concern, Mrs. Daniels said. Perhaps the killers might think the Jays were witnesses to the killings. So police kept watches on the LaPoint home and the Jay residence in Rochester for a couple weeks.

Beverly, who placed double locks on their doors, was plagued by nightmares for most of the remaining forty-five years of her life, Mrs. Daniels said.

Her father, on the other hand, shrugged it off, she said. The veteran of service in the navy died of a massive heart attack in August 1975. Within a year after his passing, Beverly moved back to Norwood. She did not drive, and she could not cope with city life. She was still afraid, Mrs. Daniels said.

Beverly Jay died on August 2, 2009, a victim of Alzheimer's disease.

Chapter 2

"ATTRACTED TO THE BAD BOYS"

A page in the 1962 calendar had just been turned a couple hours earlier, ushering in April Fools' Day. But two Watertown police officers, Sergeant William G. Keller and his younger partner, Patrolman Jack W. Ellingsworth, were not about to get any laughs that morning when their patrol duties were interrupted by a sudden turn of events.

Out of the darkness came a car heading directly toward their patrol car. They evaded a collision and then began an attempt to halt the reckless driver who had dared cross their path. The motorist, they observed, was a man.

The offender was not about to stop; perhaps he hoped to escape being identified as an unlicensed operator. Or perhaps he had something to hide.

A chase was on at 2:15 a.m., with the offender and the police patrol heading out of Watertown on Bradley Street and continuing north on New York State Route 12 at speeds reaching eighty miles per hour. Seven miles into the run, as the race passed through the hamlet of Depauville, the officers noticed a risky maneuver in the lead auto. The man and his female companion switched places—now she was driving. And she was equally determined to outrun the pursuers. That, of course, was not about to happen.

The chase continued uninterrupted for another eighteen miles, reaching the St. Lawrence River resort village of Clayton. There, the motorist attempted to make a turn, heading the wrong way on a one-way section of Riverside Drive. She was unable to maintain control of the vehicle and skidded into a utility pole. No injuries were reported as a result of the crash. Found at the wheel was Barbara Ann Egan, twenty-one, while her

husband of nearly four years, Peter W. Egan Jr., twenty-four, was in the passenger's seat.

Now that police were aware who was leading the chase, they were not surprised that the driver and passenger had traded places for operation of the car. This was a known practice utilized by this couple to keep Peter from being charged with driving while his license was suspended. Peter, who had an artificial leg, had an arrest record dating back to 1951, when, as a thirteen-year-old, he was charged in a car theft investigation, the *Watertown Daily Times* reported.

Police became interested in what they found upon opening the wrecked car's trunk: a large quantity of merchandise ranging from spark plugs to wallets and trousers.

Husband and wife were arrested on reckless driving charges. Peter was additionally cited with driving without a license, and Barbara was charged with permitting the unlicensed operation of her car. No record is found to indicate whether any charges were lodged in connection with the evidence seized in the auto.

Five or six years earlier, Peter had been a suspect in a burglary. In fact, New York State Police had a warrant charging him with the break-in. But the charge was dropped, apparently because of the crippling injury he had suffered on February 17, 1957, near Winnemucca, Nevada. After spending about eight months on the West Coast, he had hitchhiked a ride to make his way home to Watertown. The car in which he was riding went off a road and crashed. He was ejected and suffered fractures in both legs, his shoulder and his back. Following hospitalization for three weeks in Humboldt, Nevada, he was transported by train to Syracuse, where he was met by his parents. Examination at Watertown's Mercy Hospital revealed that gangrene had developed, forcing amputation of his left leg above the knee on March 11, 1957.

The son of a World War II veteran and Leona M. Fober Egan, Peter Jr. was using crutches on July 3, 1958, when he married Barbara Vout at Stone Street Presbyterian Church in Watertown. The bride, who only a few weeks earlier had graduated from Adams Center High School, was considered one of the prettiest girls in her southern Jefferson County hometown of Rodman. She was at the time employed at the W.T. Grant department store in Watertown.

Even as wedding vows were exchanged, the newlyweds were aware that they faced interruption in their marital bliss in about three months. Peter had an appointment to report on the first day of October for admission to

"Attracted to the Bad Boys"

West Haverstraw Rehabilitation Hospital in New York's Rockland County for plastic surgery relating to the leg amputation.

The union of Barbara Vout and Peter Egan perplexed her high school classmates, as they saw her "go totally overboard" and act out of character, as one of her friends in school put it. Barbara had been "cute, adorable, smart, personable, sweet and athletic," said the woman, speaking on the condition of anonymity. "In high school, she was a good girl, never swore and never stole. We girls from Adams Center didn't smoke cigarettes like the girls from Adams did."

Barbara was a cheerleader and a saxophonist in the school band, played field hockey and was a member of a library club. She was popular and made friends easily, although another girlfriend added, "She could be snooty at times."

And she was cliquish in their twenty-seven-member senior class, it seemed. Other classmates observed that she stuck closely to a tight circle of friends—three girls.

She had a "nice" boyfriend, Gerry Brown, said one classmate. "They even bought furniture together because they planned to get married," she said. "Barbara had so much personality and so much to live for, but then she met Pete."

One of the girls in Barbara's clique, Kay Hutchings Vargas, observed changes in her friend even before Egan came along, however. Barbara started showing a mischievous nature, having joined one of her girlfriends in shoplifting adventures, Kay said. "I remember getting into trouble at school," she said, and the principal "told my parents I would be better off being friends" with another girl instead of Barbara "to stay out of trouble."

Kay harbors regrets for her role in helping change the direction of Barbara's life. She said she was dating a friend of

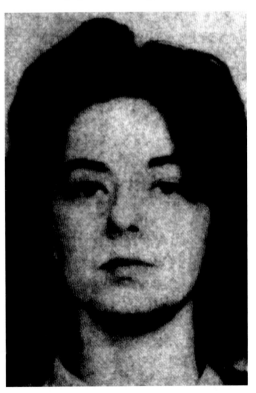

Barbara Egan.

Peter Egan, and it was through that association that Barbara was introduced to Egan at a YMCA dance in Watertown.

The pretty Barbara, with her great smile, "had no trouble getting the boys' attention," Kay said, but this Egan lad was known as a hoodlum. "It was a case of being attracted to the bad boys."

Barbara and Gerry Brown were still dating when she turned her attentions to Egan. A spurned Gerry was "very hurt," Kay said. More than that, said another classmate, "he was devastated."

Subsequently, Barbara was seen with Egan at a popular gathering place in Adams Center, the Square Dance Ranch, according to Bud Davis, eventual husband of Martha Prior, who was in that small circle of Barbara's friends. After that acquaintance, Peter was regularly seen at school dances, where, as one of Barbara's friends put it, "he stood out like a sore thumb."

Another popular hangout for this young crowd from the Adams area was the Cobblestone Bar, just south of Watertown.

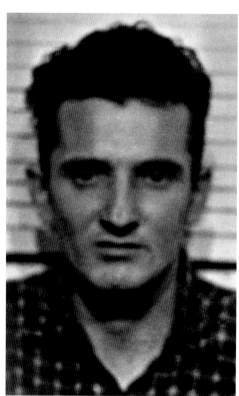

Peter Egan.

"She totally changed after she got in with Pete," said a classmate. "It was like night and day. Nobody could believe it when she started dating Pete…He was terrible looking with no personality. Pete was a horrible person, anti-social…and he looked dangerous." Peter had "a little man complex because he was so small and only had one leg," the woman continued. "That's why he was always starting fights."

Former *Watertown Daily Times* reporter Jim Brett said in a March 4, 2006 interview that he knew Peter Egan. "He was bad news. He had nothing to offer society. He had no good qualities that I know of."

As the class of 1958 approached the end of its high school career, Barbara no longer associated with her friends, although "she was

always friendly if we ran into each other at the store," a classmate commented. Instead, she hung out with Peter's "bunch."

Kay said she played alibi for Barbara when she was out with Peter, telling Raymond and Irene Vout that their daughter was with her. "I suppose if I didn't lie for her to her parents, she would have found a way to meet up with Pete," Kay said. "They finally caught me lying to them, and they were extremely upset with me."

The couple would be equally upset when their daughter exchanged vows with Egan, as Joseph Coleman would hear from his work colleague, Raymond Vout, at Northrop Motors.

"I am not sure what I could have done to save her from her tragic ending," Kay continued. "She knew it was wrong; that is why she was sneaking out with him."

As she reminisced, Kay said she could see how Barbara occasionally "used" her, particularly when she wanted to borrow a car. And there was the occasion when Barbara "borrowed my steady boyfriend," Kay said. "I had to go out of town for my grandmother's funeral, and I found out much later."

Flirting with another girl's boyfriend was actually a game in Barbara's circle. "In our freshman year, somehow we got the idea of stealing the boys from girls from the grade behind us," Kay admitted. "We took their boyfriends, boys in their class, and made them our new boyfriends just to make them mad. Those girls were so mad at us."

Peter and his younger brother, Gerald, were no strangers to the Adams crowd. Mr. Davis knew them.

"They were nothing but thieves," he said. "When somebody saw Gerald, they'd say, 'There's the God-damned Egan gang.'"

Gerald was a bigger thief than Peter, Mr. Davis said. "He was always there with his crippled

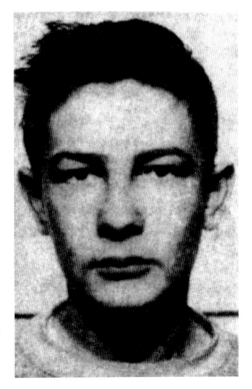

Gerald Egan.

brother. And Peter could run faster with one leg than most people can with two legs."

Gerald, said Jim Brett, "was Pete's legs. He'd send Gerald to do his dirty work, stealing, while Pete usually sat in the car."

Everybody who watched Barbara's new relationship grow believed that Peter was using "the smoke," Mr. Davis said, referring to marijuana, and it was also obvious to them that Barbara was picking up the habit. But a member of the clique suggested that Peter was actually taking a prescribed strong pain medication for his left leg and that Barbara was also using the drug.

She took up drinking, too, said a female classmate. Peter "dragged her down to his level," the woman said.

Following Barbara's marriage, one of the girls made attempts to keep in touch with Barbara. She was shocked, if not nauseated, when she visited Barbara's apartment. The former classmate recalled that as a teenager, Barbara had always done well in cleaning her father's house. But this was not her father's house. The visitor was horrified at the filth in Barbara's home, so much so that she didn't even want to sit down on the furniture.

And Barbara had let herself go. "She was no longer cute but instead looked rough and hardened."

"I was appalled to see Barb living in such despair, with three young boys having to live in squalor," the woman said.

Barbara had by this time given birth to three boys. Her firstborn arrived in 1959, followed by another in 1961 and then her youngest about a year later.

Kay never visited the Egan home. "I heard she had this monkey living with them like a dog, and it had the run of the house and was mean…and pooped all over."

Another classmate remembered when her mother-in-law was visited by Barbara, who asked to rent a cabin at Sackets Harbor. Barbara appeared to be under the influence of some substance and was in need of a bath, the classmate said. She had two of her boys with her, and they, clad only in dirty diapers, "were filthy dirty from head to toe," the woman said. Her request for the cabin was declined.

Kay was told of arrests and imprisonments of Peter and Barbara. "I do know she would stand outside the [Jefferson County] jail and yell up to talk to Pete when he was there," Kay said.

Peter "was generally a sleaze ball," as former state police investigator Ray Polett put it. Egan was building a police record of up to thirteen arrests and was gaining the reputation of being the leader of a burglary ring, although he would never be convicted as such. The fifty-seven-member Watertown Police

Department was apparently aware of the Egan brothers' illegal activities, but knowing it was not proving it. So the Egans—Barbara, too—were subjected to more than their share of vehicle stops. At least one of those came courtesy of a familiar face—Officer Ellingsworth—just seven months after the chase to Clayton. Peter was charged with speeding.

Then came a car accident in October 1963, when the words spoken by Peter left an indelible memory for all cops. Egan, still a suspended driver, denied he was operating the auto and refused to name the motorist, whom he claimed ran off. Officers reported that during that investigation, at the scene, an entrance to Watertown's scenic Thompson Park, Egan told them that before he'd be locked up again, he "would shoot it out" with police.

Peter and Barbara settled into a gypsy-like existence, making several residential moves, often forced by nonpayment of rent. Barbara, meanwhile, continued her shoplifting activities, occasionally using her sons as a cover. It got to the point that the three lads were not allowed in any Watertown stores, said one of her acquaintances. On one occasion, Barbara was detained for stealing one right shoe. This baffled the store manager, who was unaware of her husband's handicap.

She was also charged in a forgery investigation and, after pleading guilty to a reduced charge, was sentenced to probation.

Barbara also turned to prostitution, according to James Pickett, whose name would eventually become prominent in the homicide investigation. Peter was her pimp, Pickett said in an interview, driving her to Camp Drum, a National Guard training ground near Watertown, later to be named Fort Drum. There, "two-week wonders," as the local populace dubbed the military trainees, were ready and waiting for the housewife's services.

The Egans also played games in taverns, said Jim Brett, the newspaper reporter who not only covered their murders but was also acquainted with them. Barbara "got all fixed up" and went to bars alone, attracting men into conversation, he said. Then one-legged Peter would show up, and eventually they all would leave the bar together, their planned activities left to the observers' imaginations.

In another aspect of the bar scene, Peter was not one to back down from a fight. "Peter was a good fighter, even if he only had one leg," said a member of the Egans' "hangers-on," speaking on the condition of anonymity. But the outcome did not always favor him.

"One night we were hanging out in a bar, and Pete got into it with three brothers," the source recalled. "Pete went outside with the three guys, and he was fixing to clobber one of the boys over the head with his crutch when

Gerald stepped in between them to try to break them up. The guy then sucker-punched Peter and proceeded to beat the crap out of him."

Barbara felt trapped—at least that is the impression she gave Kay's mother, Annamae Hutchings. "My mom would tell me Barbara would stop in to see her," Kay said. "She told Mom she feared for her life and was unable to break away from Pete. Barb felt close to my mom, so she would confess her true feelings and fears to her."

Barbara's brother, Steven Vout, said in a brief telephone interview, "She just got caught up in it and she couldn't get out."

Peter Egan "was crazy," Vout said. "He was no good, and his brother wasn't much better."

Pickett mentioned spousal abuse in the Egan home. Polett, attributing his knowledge to people interviewed in the murder investigation, concurred.

"Peter used to bat her around once in awhile," Polett said.

From the visits to Robert and Annamae Hutchings's farmhouse on Massey Street Road, Barbara learned when Kay's parents were heading to Florida for extended vacations. During those absences, the couple's home was burglarized several times. "Police would trace it back to Pete and Barbara," Kay said.

Peter and his brother "were a lot of fun to hang with," said their anonymous friend. He denied participating in burglaries with them, but he admitted to being with them on a night when they torched a black Edsel on Perch Lake Road, north of Watertown.

Peter fell into the hands of the law as he drove off from one of his adventures. That was the night when he removed the backseat of his car and then went out and rustled a calf. He spent a month in jail for that.

Peter and Barbara were receiving public assistance benefits, their only visible income. Despite that, Peter was very generous in bars, constantly buying drinks for others. He often flashed large rolls of bills, and he was occasionally open to granting loans. Barbara was said to have complained once that if her husband had all the money he had loaned people, he would have $4,000 or $5,000. One guy owed him $1,200, she was overheard to say.

While police suspected the Egans in burglaries and thefts, Jefferson County investigated them for their unexplained access to cash. Early in 1963, the couple was removed from the county's welfare rolls. They would have to live off alternative means for the next several months, but then again, they were accustomed to that. The police investigation into their ultimate fates would later reveal just how afoul of the law their activities had become.

"Attracted to the Bad Boys"

For most of the last several months of their lives, Peter, Barbara and their three sons lived somewhat secluded from law enforcement in a house near Muskallonge Lake, nearly thirty miles northeast of Watertown. But it was another story of being evicted for nonpayment of rent. After that occurred in November 1964, the property owner found the dwelling left in shambles.

The family of five moved back to more familiar ground, making their final home at Campbell's Point, just off the eastern shores of Lake Ontario, near Sackets Harbor and a few miles west of Watertown. There, Peter challenged his handicap by participating in outdoor sports with his neighbors, according to one of those neighbors.

And now, the Egans were stepping on toes—the toes of those in their small web of friends. Rumors were out that the threat of a "hit" against Peter had been put out because of a burglary that was too close to home. He was believed to have stolen $1,000 in that burglary, and the crime victim was heard to say, "Peter is a dead man if he doesn't return the money."

Nerves in the circle of burglars were getting edgy. James Pickett said in interviews that about two weeks before Christmas 1964, he met with a gang member, Joseph Leone, at their favorite hangout, the Red Moon Diner at 455 Court Street in Watertown. Leone told him he was going to have to kill Peter Egan "to keep him quiet and keep us all from going to jail." Leone said, "Egan knows enough to put us all away for several years," according to Pickett.

"I didn't think he meant it," Pickett said.

He said he and Leone were best friends and they hung out together nearly every day for over twenty years.

Leone appeared to have a motive for revenge. On December 20, a house at 130 Duffy Street in Watertown was broken into. It was the home of Anthony G. Leone, father of Joe Leone. Anthony Leone was quite prominent in Watertown, having been a welterweight and middleweight boxer, fighting under the name "Kid Sullivan." A family heirloom diamond ring, valued at several hundred dollars, was stolen, along with $760 in cash.

For Joe Leone, there was no doubt that the Egans were responsible. The Egans' parents, Peter Egan Sr. and Leona, were neighbors at 114 Duffy Street.

Leone told Pickett he was needed to help lure the Egans to a rest area along the new interstate highway to keep the Egans from being suspicious. They knew and trusted Pickett because he had participated in a few burglaries—three or four—with them, Pickett acknowledged.

This would be the ruse: A truck was known to be scheduled on New Year's Eve to be coming up Interstate 81 and would be exiting the uncompleted

highway to a state road en route to the Thousand Islands bridges and Canada. In the rig's cargo hold would be a shipment of liquor valued at up to $16,000. The Egans would be paid $1,000 to drive to the rest area, where they would assist their trusted friend, Pickett, in hijacking the truck. Pickett would drive away in the truck.

Peter Egan agreed to the deal. Apparently, so did Gerald, who was living with his parents at 114 Duffy Street. When New Year's Eve arrived, Gerald tried to excuse himself. Perhaps he was concerned that participating in the proposed hijacking would violate terms of a probation sentence he was serving for a disorderly conduct conviction.

The conspirators to hijacking—actually to murder—would drive to the rest area in a second car. There was no way Peter would ever let somebody sit behind him in the car and get the jump on him, his associates suggested. Peter was way too observant to allow that to happen, "unless it was somebody he trusted," a source said.

As plans for New Year's Eve were in the making, the Egans did some big-spending shopping, police were later informed. They spent several hundred dollars in cash on merchandise at Century Wholesale Supply Company at 595 West Main Street, Watertown. What they purchased—or when—was not disclosed. One of their Sackets Harbor neighbors recalls seeing them in a discount store on that last day of the year.

Meanwhile, law enforcement was closing in on the Egan family. The Federal Bureau of Investigation was snooping around, and worried Egan associates were aware of it. Peter, who had been discharged on December 2 from the Jefferson County Jail after a short stay for public intoxication, apparently was not aware.

On December 22, two days after the Leone burglary, authorities were notified by an attorney about a suspicious car being stored in a hay barn off Clayton Road, not far from Watertown. The property owner, Clifford Carr, had consulted with his attorney after becoming concerned that the Egans had failed to show up with proper registration for the car. Checking with the New York State Department of Motor Vehicles, the lawyer determined the car was hot.

Police found the 1962 red-and-white Chevrolet convertible covered with a tarp and hidden behind junk in the barn. Investigators confirmed the vehicle had been stolen off a lot at Economy Rent-A-Car, 825 Fifth Street in Miami, Florida. Interviews revealed that the teenager who stole the car drove to Watertown and then traded it to the Egan brothers for an older-model Pontiac. The brothers in turn pulled off another trade with used auto parts

"Attracted to the Bad Boys"

dealer Eric C. Farr Sr., receiving for the convertible a 1945 Willy model Jeep. The Willy was a Ford-manufactured four-wheel-drive utility vehicle that was primarily used during World War II.

The Jeep was signed over by Mr. Farr to Barbara, who wrote out a sales receipt: "Received payment in full for 62 Chevy conv.," the *Watertown Daily Times* reported. The receipt was dated October 1, 1964.

Mr. Farr towed the convertible to Carr's barn, asking the latter on December 22 to install a fuel pump and store the car pending completion of the state's vehicle registration process, according to the newspaper. Carr did not suspect the car to be stolen, police said, and he placed it against a wall in his barn to make room for machinery that he needed to store. No charges were brought against the buyer, perhaps in exchange for his cooperation with police.

As the final days of the year rolled by, a rumor persisted. Somebody was out to get the Egans.

According to trial testimony and interviews, here is how the final hours in the lives of the Egan trio transpired on New Year's Eve.

Peter, at an unspecified time, rushed into the Windmill Café at 404 Court Street, Watertown, a bar renamed the Hitchin Post Tavern three years later. He was known as a frequent visitor.

An "extremely nervous and excited" Peter said he needed to borrow a shotgun. He was worried about possible repercussions because his associates had burglarized a certain home more than once, a place they shouldn't have hit.

Perhaps the rumored death threat was getting to him. When Peter left the bar, he was apparently still unarmed.

Peter and Gerald, at about 4:45 p.m., went to the Rotary Gas station at 443 Court Street, visiting with station owner Joseph Mastascusa, station attendant Richard K. Woods, Joseph Leone, Pickett and another man identified as Paul Charlebois. Peter asked Gerald to join him for the evening on a mission, but Gerald begged off, saying he had a date. Leone urged Peter to let Gerald go on his date.

In the meantime, there was talk of celebrating the holiday—after the night's mission was completed. Peter invited Leone and Pickett to join him and Barbara at Watertown Bowl, located on Route 11, just south of the city limits. Leone declined, explaining that he never cared about going out on New Year's Eve.

As Peter talked about celebrating, he was haunted by the death threat. "Might as well have a good time because tonight might be my last night," he said while playing a pinball machine in the Rotary station.

The Jefferson County Egan Murders

Their gathering then transferred to the nearby Red Moon Diner.

Barbara was not present at the time, but at about 6:00 p.m., she drove up to the Rotary station, made a two-dollar gas purchase and picked up the Egan brothers. She had at least one of her children, but possibly all three, with her. Peter, Barbara and Gerald proceeded to the home of the brothers' mother, Leona, at 114 Duffy Street, and dropped off one of the children. When they left, they gave no indication of where they were going. At some point, probably before reaching Leona Egan's house, Barbara delivered two of her sons to a babysitter's house and put her hair up in curlers, getting ready for the night out.

Barbara Egan's car had a leaking gas tank. Even after she had purchased about seven or eight gallons at the Rotary station, her husband spent another two dollars on gas at about 7:30 p.m. at Green's Gas, 810 Bradley Street.

"This is the only car getting tanked up on New Year's Eve," the station attendant quipped to Peter.

Gerald went inside the station and bought two pairs of work gloves, a six-pack of beer and a six-pack of Coke. His brother and Barbara were reported to have remained in their car. Following the murders, only one pair of gloves was found in the car, leading police to say that they "could solve the murders if they could locate the other pair of gloves."

Near Green's Gas, in the 500 block of Bradley Street, Peter was seen talking with somebody in a late-model blue Chevrolet sedan.

That was the last time Peter, born on May 15, 1937; Barbara, born on June 17, 1940; and Gerald, born on July 22, 1945, and remembered by an elementary school classmate as a "class clown" who was "always in trouble," were apparently seen alive in Watertown. The two brothers and Barbara presumably drove northeast on Bradley Street for a mile until they came to a right turn, the northbound on-ramp to Interstate 81. Then, the final one-mile drive of their lives brought them to the pull-off that to this day is remembered unofficially as the "Egan rest area."

The time of their deaths was estimated by Dr. Richard S. Lee to be about 7:30 p.m. or shortly thereafter.

Later that evening, the time not specified, patrons in the Windmill Café witnessed an outcry from Leona Egan. Mrs. Egan liked her booze and was a frequent customer at taverns, but not to the extent of her late husband, who was known for being a town drunk. He had died at the age of forty-seven, seventeen months earlier.

"They killed them," Mrs. Egan cried out hysterically. "They killed my boys. They're both dead up at the hospital."

"Attracted to the Bad Boys"

James Pickett denied carrying out his assigned role in the conspiracy. He said he became aware of the triple homicide when a special bulletin was aired that night on Watertown's television station, WCNY, Channel 7.

"I knew right away that Joe Leone killed them," he said. When he had been invited into the plot a few weeks earlier, "I thought Joe was running off with his mouth but didn't really mean it.

"I couldn't kill anybody," he said.

Pickett had breakfast New Year's Day at the Red Moon Diner with Leone and his girlfriend, Beth Johnson. "Leone acted surprised when I told him that the three Egans were murdered," Pickett said. "Joe acted like it was the first time that he'd heard about the murders."

Three or four days later, Pickett and Leone met again at the diner. At that time, Pickett claimed Leone admitted to the killings "to keep them quiet" and named an accomplice, Willard Belcher.

It would take state police only a few days to narrow down their field of suspects to four names: Leone, Pickett and Willard Belcher, along with Belcher's wife, Bertha, "a working prostitute at age eighty," Ray Polett said. But it would be years, not days, before arrests would be made and before only one of them would be brought to trial.

A single funeral service was conducted for the three murder victims on January 5, 1965, at the Simpson Funeral Home in Watertown, with a Methodist minister, the Reverend John J. Kelly, presiding. Those who went to calling hours were surprised to find three open coffins considering each person had been shot in the head.

Chapter 3
"LAW ENFORCEMENT IN HIGH GEAR"

For a year or more, two state police investigators, Ray Polett and Charlie Donoghue, spent their shifts, sometimes together and sometimes in rotation, sitting in a cellar, eavesdropping in hopes of hearing incriminating comments by suspects in the Egan murders.

"I hated that detail," eighty-two-year-old Polett said in a March 2014 interview in his Punta Gorda, Florida home. "I suffered through that, sitting in a cold damp basement, being cold, hungry and thirsty, with cold feet, usually working it noon to eight at night. I met Donoghue working that case. I didn't like him at first, but we became close. We were a lot like the odd couple, but we worked well together."

An informant, not identified but old enough to have a seven-year-old grandson, allowed use of his home, about two blocks away from the targeted 315 High Street, Watertown home of Willard and Bertha Belcher, to listen to phone conversations. State police had burglarized the Belcher home to plant a bug. Polett said a trooper who was a locksmith got him and Donoghue into the house:

> *We were like the Keystone Cops. We overturned a sofa, pulled away the bottom fiber, then planted the bug in the sofa frame. Charlie had brought his staple gun from home, and I started using it to staple the fiber back into place. But the gun was empty. Charlie said it was loaded yesterday!*
>
> *Now the clock was ticking. We had to get this done before Belcher got home, but we had to go across the city to Charlie's house, get staples and come back. Luckily we got it done* [about 10:00 p.m.], *before they returned.*

The Jefferson County Egan Murders

Left: Raymond Polett. *Right*: Charles Donoghue. *Courtesy Mary Donoghue Fraser.*

While enduring the discomforts of the cellar, the investigators had moments that occasionally broke the boredom in their assignment, Polett said. There was the day that the stakeout was nearly exposed, not by the suspects, but by the hosts' grandson.

> *The boy came down the cellar stairs and saw Charlie and me. He ran back upstairs, put on a cowboy hat and toy gun, then came back down, pointed the gun at me, cocked it and pulled the trigger. I acted like I got hit and fell back. He ran back upstairs, and we never saw him again.*

A favorite Willard Belcher term was "rat bastard," Polett said, "and we heard him say, 'I'd like to put a bullet in that rat bastard's head' a number of times. I heard him say that about me."

But what the investigators needed to hear, they did not. "There was an exaggeration made that Willard was heard laughing and joking on the tapped line about how the Egans died. He never said anything to link anybody to the murders."

Willard Belcher loved loud noises and was often heard in his phone chats making comments about big booms or bangs, Polett said. But there were no specific references to gunshots.

"Law Enforcement in High Gear"

Most entertaining were calls taken by Bertha from her lovers, all close to her in age, Polett said. One old guy told her repeatedly how he really loved her, while another, bemoaning his impotence, was assured by Bertha, "Don't worry, honey, I'll take care of that," Polett recalled with a chuckle.

Police had the goods on a prostitution case, but that wasn't what they were looking for. "We were focused on getting murder charges," he said.

THE BELCHERS AND JOSEPH LEONE were suspects "within days" of the triple homicide of December 31, 1964, according to Polett. "They had quite a few friends" who gave information during interviews, he said. "I'd say Leone's name came up first. Many people were dropping his name."

Joseph Richard Leone gave a statement to police on January 3, 1965, during which he made claims about his whereabouts at the time of the murders, according to a New York State Court of Appeals document.

Within the first month of the investigation, police said at least five hundred people were questioned, and to rule out a possible link to drug trafficking, the Buffalo branch of the Federal Bureau of Narcotics joined the probe. Also checked were known gamblers, but that proved to be a dead end in the search for a motive.

Investigator Donoghue told reporters that the quest for a motive was confounded by Peter Egan's habit of bragging about his activities. "He had a vivid imagination in some of the stories he told," Donoghue said, referring to several people he interviewed.

Donoghue offered his theory of what happened on New Year's Eve: the killer "blew his top," shot one Egan on the "spur of the moment" and then had to finish off the others.

Several people who were questioned agreed to take lie detector tests. Leone was among them, consenting on May 8, 1965, after state police informed him "they did not believe his account of his activities," based on information they had developed, according to the court of appeals document. He was not administered the polygraph until July 1966, the court document indicates.

Everybody "passed," police told reporters.

Leone was a guy who had been a standout football player when he attended Watertown's Immaculate Heart Academy high school. He was the nice driver-salesman for Wonder Bread who gave treats to kids along the truck route that had been his for up to eighteen months. His niece called him her "favorite uncle—he was a good man and a great uncle."

His friends saw him as mild-mannered, congenial, not a drinker and never in fights.

"Joe was very popular," said James Pickett, who would be charged and then quickly uncharged in the investigation. "Everybody wanted to be Joe's friend because his father was Kid Sullivan. Joe knew everybody everywhere he went."

Kid Sullivan was actually Anthony G. Leone, who, born in Sicily, came to the United States in 1913, when he was thirteen, with his parents, Guiseppe and Francesca Ditta Leone. One of eight children in Guiseppe's family, Anthony was in his mid- to late twenties when he entered the ring as a prizefighter to supplement his income as a construction worker and laborer.

"Boxing was big in the flats [a reference to an area of Watertown settled heavily by Italian immigrants], a good way to make money in the '30s," said Larry Corbett. "Get beat up."

Relying on a rugged style of combat, Leone slugged his way in welterweight and middleweight divisions at Syracuse, Utica, Ogdensburg and Watertown in the 1930s. "Kid Sullivan," whom the *Watertown Times* dubbed the "local caveman," became a fan favorite at matches at the Knights of Columbus and Odd Fellows neighboring buildings on Stone Street and at the Starbuck Arena, across from New York Air Brake Company. His won-lost record was nothing to boast about, however.

There are stories to this day that Kid Sullivan even wrestled a bear, although there are no press reports to confirm this.

Murder suspect Joe Leone was at the time separated from his second wife, Anita, and was living with another woman, Beth Johnson. His first marriage, on February 18, 1950, to Norine, a fellow student at Immaculate Heart Academy, ended in divorce after five years. Before securing his job delivering bread, he had skipped around from one employer to another in Watertown, including the California Fruit Company store, Crescent Beverage Company and Arsenal Beverage Company. He also filled in as a gas station attendant.

Leone and Peter Egan were longtime friends and for many of their formative years had been neighbors.

Unsuspecting landlords of Joe Leone and Beth Johnson may not have been aware when an apparent piece of stolen property changed hands. The couple rented an apartment in the house at 114 Central Street owned and occupied by Cosmo and Rose Marie Amedeo. Leone knew that Cosmo was looking for a television set, and he told Peter Egan, who stopped in and said he had a TV to sell.

"Law Enforcement in High Gear"

"Pete Egan was in my house once," said Joseph Amedeo. "He sold my dad a TV. I'm positive it was hot. But my dad would not have knowingly bought stolen property."

Mrs. Amedeo was a first cousin of popular singer Tony Bennett, who had visited their home.

Amedeo said he heard a few arguments between Joe and Beth, "and they sounded pretty bad, but not often, perhaps a couple times."

Leone lived in the Amedeo duplex for about ten years, Amedeo said. "There was not a lot of coming and going" at the Leone apartment, he said.

Bertha Belcher was second oldest of four girls, born in 1897 to Frank and Mary Jane Smith Cushing. After Bertha's father died while she was still a child, Mary Cushing moved the family to Gouverneur, New York, and remarried. That relationship had ended by 1920.

Bertha, in the meantime, experienced a failed marriage. She was about eighteen when, in 1915, she became Mrs. Lawrence Montondo, but the marriage was dissolved in 1919.

Little more than a decade later, Bertha Montondo's name was beginning to appear on the Watertown police blotter. She first made headlines in May 1932, thanks to a Watertown police raid at her 457 Newell Street home. City police came searching for a man believed to be transporting alcoholic beverages. Although fourteen bottles of home brew were found in the house, and the runner was discovered in the attic of Bertha's house, no arrests were reported.

She had moved to 238 Coffeen Street by April 1936, when Watertown police again visited her. Although Prohibition had been repealed by then, police conducted an investigation at Bertha's house after a soldier assigned to Madison Barracks, Sackets Harbor, revealed that he had purchased liquor there. She was cited with keeping a disorderly house.

Eyes turned to her again in July 1938, when Bertha came under suspicion of running a house of prostitution at her newest address, 936 Arsenal Street. She, along with three other women and a man, was arrested in an investigation prompted by a man's complaint that $300 in veterans' bonus money had been stolen from him at her house. Prosecution fell through after the complainant was exposed as having served time in federal prison for attempted extortion.

But police were watching Bertha's house, and before the year was over, on December 11, her home was raided. She and two women were arrested, and five men were charged with violating the public morality clause of a city ordinance. Bertha subsequently pleaded guilty to operating a disorderly house.

Ten years later, on October 3, 1948, she married Willard, the owner of a small trucking business. She was considerably older than him.

Bertha had a daughter, Sharon, who died at age five.

She "was a mean lady and ran a lot of houses of ill-repute," one of her nieces said in an interview. "She was no mother figure to anyone but her working girls."

The niece, wishing to not be identified, added, "She was a mean witch to all kids. When we visited our uncle and aunt, she was always mean, unfriendly and rotten to us."

Bertha was also an abortionist, the niece and another source disclosed.

Willard was "a kind, outgoing, fun person to be around," the niece said. This was her opinion, not Ray Polett's.

"Willard really hated Donoghue and I," Polett said in an interview, "telling me that 'I could kill you, Polett.' I responded that he probably could, but 'you are too nice a guy to do that.'"

Willard, who was forty-nine when the Egans were gunned down, had apparently had only one encounter with the law, according to *Watertown Times* archives. That was in November 1962, when he was accused of assaulting his boss, Mitchell Roberts, at Deluxe Lines, a trucking business at 424 Newell Street in Watertown. Roberts had fired him for continually being late for work. Belcher pleaded guilty to disorderly conduct and returned to being a self-employed trucker.

A Valentine's Day baby in 1915, Willard was one of four children whose alcoholic father, James, was known for beating his twenty-one-year-old wife of six years, Beatrice. The man of the house—a filthy apartment—was forcing his wife to have relations with immigrant highway workers to bring in money, alleged Watertown police, who in November 1915 charged James Belcher with living off the proceeds of prostitution. He escaped from the Jefferson County Jail and crossed the border to Canada, where he joined the army to serve in Cyprus in World War I, according to his descendants.

Family sources also say that Beatrice served prison time for harboring draft dodgers while James was serving in the Canadian army.

On September 22, 1919, the Belcher siblings, with a father living somewhere in Canada, became orphans. Their mother was lost when a freighter, the *TJ Waffle*, on which she was the only woman aboard, sank in a storm on Lake Ontario near Oswego, New York. The recovery of splintered debris led to speculation of a boiler explosion. Mrs. Belcher was the cook aboard the craft, which was bound for Kingston, Ontario, Canada, with a load of coal. She and all seven crewmen drowned. The body of a woman, headless and without

"Law Enforcement in High Gear"

hands or feet, was found the following year at "Toads Hole," Dexter, and was presumed to be the remains of Beatrice Belcher. The remains were not positively identified and were buried in the Dexter cemetery.

When Willard was about eight years old, his father is said to have died in Canada from a lingering disease linked to his war service.

Willard's remaining formative years were split between the western New York cities of Rochester and Buffalo, and by the time he returned to Watertown as a young man late in the 1930s, he had taken up boxing, entering the ring under the name "Kid Kelly" or "Kelly Belcher."

IN THE SECOND FULL day of the investigation, state police were saying they believed there were at least two gunmen, but they had not yet arrived at a motive. Police were not about to say anything yet, but a turn of events three days later made it quite clear to the *Watertown Daily Times* that police were on to something. The paper observed in a January 5, 1965 editorial:

> *Coincidental or otherwise, the wheels of law enforcement, set into high gear following the investigation of the triple murders...have resulted in a series of arrests and the solution of crimes.*
>
> *Since Sunday night seven persons have been taken into custody by the sheriff's office for burglaries and criminally receiving stolen property... These minute investigations (by troopers, the sheriff and Watertown police) quickly led down other paths, apparently, and the series of arrests for burglaries followed.*
>
> *It is interesting to note that an accused burglar had a business relationship with Peter W. Egan Jr.*

The reference to an accused burglar involved a man identified as Earl William Bennett.

A part of the New Year's Day investigation had troopers and deputies checking property on Military Road, Sackets Harbor, where Peter and Barbara Egan had been spending the last three weeks of their lives. Police found a .38-caliber Colt revolver hidden in a garage and a .32-caliber semiautomatic rifle tucked away in a chicken coop. The handgun, they determined, was not used in the murders, but what was interesting about the rifle was that it had been stolen from Seaway Sport Shop, at 521 West Main Street in Watertown.

Jefferson County sheriff Robert B. Chaufty revealed on January 6 that Bennett had sold the rifle to Peter Egan for fifteen dollars just ten days before

the murders. Bennett, twenty-eight, was among three people arrested on Sunday, January 3, for burglary. Bennett admitted to obtaining the gun in a trade with a man living in the nearby village of Black River, the sheriff said.

Egan, according to Chaufty, had told Bennett, "I don't know what the hell I'll do with it."

Bennett would later be convicted of second-degree grand larceny and was sentenced to probation. An accomplice, Gay O. Cooley Jr., twenty, pleaded guilty to attempted third-degree burglary.

The homicide investigation now had taken on a focus, and on the fourteenth day after the murders came the big break that police needed. Two more burglary arrests were made, and one of the suspects, who only recently had turned sixteen, had a story to tell. Investigators were all ears as Dale Glenn (an alias assigned by the authors) gave up the story of the Egan crime circle. The names he dropped would eventually send Polett and Donoghue into their eavesdropping hideaway.

Glenn, living in Canastota but formerly of Watertown, told police he was involved in at least forty burglaries in association with the Egans. He could not recall all the crimes, but he was able to list about half of them. One incident to which he admitted was at the home of Roy E. Dumas, on Black River Road near Watertown, which occurred thirteen days before the murders. The Egan brothers and Barbara were all involved, he said. Some coins were stolen, including a rare 1794 half dollar. Only about 5,300 such coins were believed to be in circulation. Today, five decades later, one in good condition might sell for more than $72,000.

Glenn told police he had accompanied the Egans to the home of Willard and Bertha Belcher on the night of the Dumas burglary, and he saw the half dollar being sold to Willard. The sale price was not disclosed, but Glenn revealed that his share for helping out in the theft was five dollars.

There was also a Christmas card from Gerald Egan that gave Glenn a bonus of $25. That brought to $100 his total take for participating in a spree of burglaries over the last seven months of the Egan trio's lives.

State police alerted coin dealers and pawn shops about the hot half dollar and then waited until May before they were notified that it had changed hands. Investigators were informed that Willard Belcher had arranged a transaction through Carl E. Hofmann, a coin dealer in Syracuse, to sell the half dollar to Dr. Bennett Rosner of Fayetteville, New York.

No immediate action was taken to press charges. Instead, the bug was planted for the Polett-Donoghue effort. The public, meanwhile, could know only that a bunch of burglaries were being investigated.

"Law Enforcement in High Gear"

Glenn, according to *Inside Detective* magazine, told police that the Egans sometimes sent out two different teams on a night to steal and loot. The Egans would make a big list on paper of the several places they intended to hit on a given day or night, police were told. Jim Brett, former *Watertown Times* reporter, suggested in an interview that Bertha did housecleaning at some of the burglary sites and told the Egans where her customers placed money and valuables.

With the information provided by Glenn, police put together the following list of solved cases in those final seven months:

June 6: Seaway Vending, 1543 State Street, ten cartons of cigarettes
June 22: Jeff Bottling Company, 449 Martin Street, associated with Pepsi-Cola Bottling Co., $1,000 cash
July 3: Mildred DeJourdan apartment, 203 Arsenal Street, $15,000 cash belonging to Ruth Sutton; DeJourdan and Sutton are sisters of Bertha Belcher
July 4: Seaway Vending again, $10
July 21: K.O. Charlebois Tire store, 465 Court Street, cash
August 26: Theodore Forepaugh residence, 1142 Arsenal Street, $1,600 in loot
August 26: Clobridge Plumbing and Heating, 454 Court Street, small change
August 26: Great Northern Salvage, 430 Court Street, attempt only
September 7: Robert Gow residence, 165 High Street, old coins, watches, rings
September 15: Francis Lyng residence, 810 Arsenal Street, $9.30 and $2.50 gold coin
September 15: Vacant house, 816 Arsenal Street, nothing missing
September 26: Martha Casler residence, 261 Paddock Street, nothing missing
September 27: Watertown Agway Co-op, 921 West Main Street, keys and $11
October 12: William Kumrow's North Side Barber Shop, 508 LeRay Street, safe containing $1,530 coin collection
October 12: Emerson Laughland residence, 531 Hycliff Drive, watches and cigarette lighters
October 18: Forepaugh residence again, TV, mandolin and rifle
December 6: Gerald Smith residence, 228 Colorado Avenue, rare coins
December 18: Dumas residence, Black River Road, coins
December 21: Anthony Leone residence, 130 Duffy Street, $760 and ring
No date: Cody's Grill, Brownville
No date: Trailer court office, outer Washington Street, no entry
No date: House on Route 180 near Limerick

The Jefferson County Egan Murders

The *Watertown Times* again took notice in its editorial column:

> *It is regrettable that it took a triple slaying to bring a solution to the numerous burglaries that had puzzled the authorities for months. The victims in the murder mystery had long been under surveillance by the police and county authorities but they worked cleverly and shrewdly in carrying out their criminal activities...One beneficial result of the Egan murders is the abrupt end to the numerous burglaries which have been a thorn in the side of the authorities for months. The Egans were the mainspring of the burglary wave and they had become expert in carrying out their program successfully until they came up against the wrong person or persons, suspected by the authorities of being identified with smalltime rackets.*

The flurry of activity in January 1965 was followed by calm. For the next eighteen months, by all appearances, the investigation had fallen into dormancy. A *Watertown Times* reporter noticed in August that the Egan death car, held in storage at the Watertown state police headquarters since the murders, was no longer there. Investigators did not reveal where it had been taken, but the likely answer might have been to a laboratory for closer examination.

The *Watertown Times* and Syracuse newspapers asked on occasion if there were any new developments and were assured by state police that progress was being made.

"We definitely have some ideas" about the identity of the killers, senior investigator Jerome J. McNulty was quoted as saying on September 4, 1965. "The possibility of solution of the crime is brighter...we are making definite progress."

Nearly four months later, on the first anniversary of the slayings, Captain Harold T. Muller added, "There are a few people who keep our interest." The killings were "a local problem" linked to the rash of burglaries, he confirmed. Narcotics trafficking, gambling and a gangland hit had been ruled out, he said.

The person in the Chevy, the last person believed to have seen the Egans alive on Bradley Street, had been "tentatively" identified, he said. There would be no further revelation about that person's identity, however.

"Law Enforcement in High Gear"

"Stolen Coin May Be Clue in Egan Case"

The July 26, 1966 headline in the *Watertown Daily Times* announced new life in the homicide probe. All the talk about arrests in burglaries being a link to the triple murder probe, and all the certainty that the gunmen were local people, seemed to have subsided. Behind this curtain of silence, however, were Polett and Donoghue doing their listening and recording as Willard and Bertha had their telephone chats. Suddenly, that ended when the couple's son, Gary, discovered the bug and pulled it.

"An alert neighbor tipped us off that a telephone truck was parked in our driveway while we weren't home," Gary Belcher said in an interview. "The neighbors watched our house with cat eyes."

The time had come for state police to spring into action with the one solid lead they had. Willard Belcher, fifty-one, was arrested on a charge of receiving stolen property. The investigation about the half-dollar coin that was stolen from the Roy Dumas house thirteen days before the Egan murders was made public. Willard denied, of course, that the coin in question belonged to Dumas. He had purchased it from a coin dealer in Toronto, he claimed. He wasn't sure of the dealer's name—Hunt or Hunter, he suggested. Police checked it out. No coin dealer having any such name was found in Toronto.

On the day of Willard's arrest, police alleged that Bertha gave permission for a search of their home. The search by Polett, Donoghue and state trooper Warren E. Creamer yielded an army .45-caliber pistol on the floor beneath a chest of drawers in a second-floor bedroom. Bullets were found in a drawer. The gun, however, was determined not to have been one of the murder weapons in the Egan deaths.

Willard and Bertha were charged with illegal possession of a firearm, but the count was eventually dropped for both on grounds of improper search and seizure methods. Willard was going to prison, however. Convicted of attempting to receive stolen property, he was sentenced to a term of two and a half to three and a half years.

Authorities had one of their suspects right where they wanted him, but not for murder. That was OK because now police could plant the seed for a war of nerves. When newspapers came out with second-anniversary stories about the unsolved murders, state police confirmed that an offer of immunity from prosecution was being considered for the murder accomplice who turned on the others. Such a move might have each of the killers fearing that the other might turn state's evidence, police suggested.

Perhaps the strategy was striking a nerve. Was it only coincidental that Joe Leone, a known friend of the Belchers, a man already questioned in the murder investigation, was selling a piece of property within two months of the Willard Belcher arrest? A routine announcement on September 28, 1966, in the *Watertown Daily Times* disclosed that Leone had sold to his mother, Fern, a lot in the town of Watertown.

The investigation turned toward Carthage, about eighteen miles east of Watertown, following a shooting in that village on October 7, 1966. Three boys had been throwing vegetables at the home of Julius Ferry, at 547 Adelaide Street, and they took off running when the eighty-three-year-old property owner emerged with gun in hand. Mr. Ferry fired, wounding one of the kids, thirteen, in the thigh.

When police confiscated the weapon, they determined that it had been stolen. Mr. Ferry disclosed that he had obtained the gun a few years earlier from Peter Egan. A link to Egan was established, but as far as being connected to the homicide investigation, the gun proved to be a dead end for police. Charges were filed against Mr. Ferry, but five years later, a jury gave him an acquittal.

As state police continued their focus on the Belchers, they reviewed the recordings made during the eavesdropping. The bug did not pay off, Polett acknowledged. State police used what they could from tape recordings of phone conversations to obtain arrest warrants in the high-profile investigation.

"The basis for an arrest warrant was shaky," Polett said. "We had nothing that strong to go with."

Hence, evidence was subsequently obtained on the strength of a warrant that was partially based on the bug. "That would be an accurate thing to say," Polett said.

Meanwhile, a Watertown police detective assisted state police by visiting a psychic. John C. Dawley brought his son Tom along. The psychic, according to Thomas Dawley, an eventual Watertown cop, said one killer spoke in broken English, had been a fighter and "had pictures all over him." It was no secret that Belcher was a fighter, and he had tattoos, but his English was fine, Ray Polett said.

Police still had that kid burglar, Dale Glenn, who was being convicted for his admitted roles in burglaries and was being granted youthful offender status. As such, his records were being sealed by the court. Investigators talked to him again in early March 1968. The chat paid off. Glenn told police they needed to interview a man who had information about who killed the Egans. And Glenn told them who that man was: James H. Pickett.

"Law Enforcement in High Gear"

The name had surfaced previously, although not disclosed by police, and certainly he had been questioned because Pickett was known to be a friend of the Egans. But hardly could this guy be seen as being knowledgeable about the murders. Just a couple months shy of his thirty-seventh birthday, he had no criminal record, and he was a family man, the father of two boys (one outside his marriage) and two girls ranging in age from two to about eighteen or nineteen.

A high school dropout, he had entered the army in 1949, and while stationed at Fort Meade, Maryland, he met a Baltimore girl about his age, Dolores. Upon discharge in 1952, he brought Dolores home to Watertown as his wife and settled into a civilian career of being a truck driver and heavy equipment operator.

Pickett was brought in for questioning, but investigators found him none too cooperative. They alleged that in two days of questioning, he "used deception in preventing state police from apprehending a person who has committed murder."

According to Pickett, he was shown a death photo of Barbara Egan and was asked if he could identify her. After he could not, he said an investigator showed him a photo of a nude female corpse and asked, "Does this refresh your memory?"

Early in the afternoon of Saturday, March 23, 1968, troopers found Pickett at the Red Moon Diner, at 418 Court Street, and arrested him on a warrant charging first-degree hindering prosecution. The arrest, said District Attorney William J. McClusky in his fifteenth month as county prosecutor, marked a "major break" in the Egan murder probe. The arrest resulted from "new information," something that left "nothing to change" the belief that the murders were tied to burglaries, he said. He added that more arrests could be expected in the "near future." Polett, on the same day, added, "It really looks like things are going to develop." Other arrests, he said, "are very imminent."

Joe Leone enjoyed going to the movies. Apparently, that's what he did on Sunday, March 24, either at the Town Theatre on Public Square, where *West Side Story* was showing, or at the Olympic Theatre on State Street, with *America America* as the featured film. As was his habit when a show let out, he stopped in at the State Restaurant, at 302 State Street, to hang out with some friends and play cards. A member of the group that evening—there were six to eight guys there—found nothing wrong with his demeanor. He was the same old Joe. At least one member of the group (his name is withheld by request) said he was totally unaware of Joe's involvement in criminal activity.

The Jefferson County Egan Murders

Murder suspect Joseph R. Leone in custody at the Jefferson County Jail, guarded by Deputies Raymond Pacific (left) and Gordon Barker.

"Law Enforcement in High Gear"

Likewise for Joe Amedeo. "I would never have thought that he could do anything like that. I always felt that Joe was a very nice guy," said Amedeo, who was about nineteen when his in-house neighbor was arrested.

The next day, Leone was back at work. For a while.

"His truck was running late," said Ray Polett. "When we finally arrested Leone, he was in his truck delivering bread and other baked goods for his employer. Donoghue and I staked out his route and finally saw Leone pull up to a stop" at the Genter and Brenon Grocery in Brownville.

Leone was actually a passenger in the truck, learning a new route, he said. "As he got out of his truck, we jumped out and collared him and took him into custody without incident." Described by Polett as "in pretty good shape, athletic," and by the *Watertown Times* as a "slim, quiet, dark-complexioned brown-eyed man with thinning brown hair," Leone was brought to the state police station outside Watertown, where he was subjected to "an intense interview."

"He was not impressed, to put it mildly," Polett said. "Leone was one of the coolest people I ever met. While I was giving it my best shot, he took a nickel out of his pocket and coolly balanced it on edge, looked at me and grinned, to show me he wasn't shook up."

On the same afternoon, Bertha Belcher, seventy-one, was arrested at her home and was charged with being an accessory to murder.

Curiously, just four days earlier, Bertha had posted a $500 property bond for the release of the Egan brothers' mother, Leona M. Egan, forty-nine, from the county jail. She had been charged by Watertown police with public intoxication in an early morning arrest in the parking lot at Phelps Apartments, at 232 West Main Street. Her live-in boyfriend, Delbert E. Leween, forty-three—a roofer remembered by Larry Corbett as "a quiet guy" who

This *Watertown Daily Times* news clipping shows Bertha Belcher in custody on the night she was charged with being an accessory in the Egan murders. She was under the guard of Jefferson County sheriff Robert B. Chaufty and Mrs. Chaufty, who served as jail matron.

was a Canawaga Mohawk from Deseronto, Ontario, Canada—was arrested in the same incident on charges of disorderly conduct and resisting arrest.

Bertha was known for posting bail for her acquaintances, according to her son, Gary Belcher.

James Pickett alleged in an interview shortly before his death that Bertha was arrested because the murders were "all her idea; Bertha ran the show." He characterized Bertha as a "mean, ruthless person" and claimed, "Everybody did what Bertha said." He alleged that she disposed of the bloody clothes and weapons on the night of the murder.

Leone had known her for years, and "they were real tight," Pickett said.

Leone and Bertha Belcher were taken on the evening of their arrests to the home of Pamelia town justice Allen S. Gardner for arraignment. "Both she [Bertha] and Leone appeared visibly shaken as they were led by troopers from the arraignment," the *Watertown Daily Times* reported.

Reality had set in. Joe Leone appeared that night to no longer be the Mr. Cool whom Polett had confronted during questioning.

Joe Rich, a Channel 7 newsman at the time, remembers that night outside the Gardner home and the concerns it left for him and his wife:

> *I wanted to get film of Ma Belcher coming out of the justice's home, but would I be able to flood the front of the home with enough light to get some good shots? A cameraman put out as many lights as he could find at the station on Champion Hill, and as soon as they exited the judge's home, on went the lights, so bright that Ma Belcher had to cover her eyes. It was then that she yelled out, "Who did this?"*
>
> *Someone yelled, "It was Joe Rich from Channel 7." Everyone could hear her reply, "I'm going to get him for this."*
>
> *My wife, Carol, said after that she had observed a car that parked in front of our home on Gotham Street for several days.*

Investigator Donoghue cautioned newsmen against making attempts to interview Leone or Mrs. Belcher, saying that any information should come from the district attorney.

On the same day Leone and Bertha Belcher were arrested, McClusky obtained a warrant charging a second person with murder. He delayed until Tuesday, March 27, to disclose the identification of the other accused killer: Willard Belcher. A warrant was filed at the Clinton Prison in Dannemora for the arrest of Belcher, who was serving his sentence in the Dumas stolen coin case. Within the next three days, the district attorney was informed that Belcher

"Law Enforcement in High Gear"

would likely never be eligible for prosecution. Several months earlier, he had been committed to a state hospital for the criminally insane at Dannemora.

"Willard Belcher was an odd man," Pickett said. "He always walked the streets of Watertown carrying a loaded .45. Everybody was afraid of Willard because they knew he was certified crazy."

The charge against Pickett was dropped after Leone and Bertha were arrested. When District Attorney McClusky was asked if the dismissal indicated that Pickett had suddenly decided to cooperate, he told a reporter, "Draw your own conclusion."

Bertha Belcher was released on bond to await her day in court. Leone's home for the next 667 days would be the county jail.

His jailers told the *Watertown Times* that Leone was a model prisoner and occupied his time by reading, playing cards and doing crossword puzzles. He also "had fun" peering out his barred window of the three-story jail located at the corner of Coffeen and North Massey Streets, watching state police

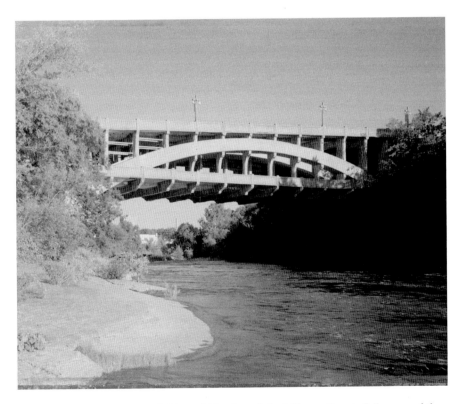

Watertown's old Court Street Bridge, within view of the Jefferson County Jail, spanned the Black River where police were told the Egan murder weapons were tossed.

The Jefferson County Egan Murders

State trooper James L. Lafferty on a boat assists diver Matt Holmes in a search in the Black River for murder weapons. The guns were never found.

divers search the Black River for the Egan murder weapons, Deputy Sheriff Thomas P. Belden told Joe Amedeo.

Diving efforts were conducted in April 1968 and again in August in the vicinity of the Court Street Bridge, within view of the jail. The August effort coincided with a lowering of the water depth from about twenty feet to six feet for the demolition of a nearby dam. But the guns were never found "because they didn't look in the right God damn place," Pickett told one of the authors.

Meanwhile, as McClusky prepared to convene a grand jury to hear the murder case, he was irked by a *Watertown Times* decision to list the names of ten potential witnesses. He was concerned that name disclosure could place witnesses in fear of reprisal. Attorney Paul R. Shanahan, of Syracuse, representing Leone, and Donald M. Palmer, of Watertown, Mrs. Belcher's lawyer, were not concerned. A guilty defendant "knows who the witnesses are," said Palmer. Besides, the disclosure helps an attorney to prepare his defense for an innocent client, he said.

Those named by the paper were four state police members, Donoghue, McNulty, Robert VanBenschoten and William Anderson; Dr. Lee; Pickett; Beth Johnson; Richard Wood; and Leona Egan and her live-in boyfriend, Delbert Leween.

CHAPTER 4

THE LONG WAIT

"You are finally getting your day in court," said *Watertown Daily Times* reporter James Brett. His comment was directed to a man staring at a possible death penalty.

"It's about time," responded Joseph R. Leone as they awaited the opening of proceedings on January 5, 1970, in Jefferson County Court.

"How many months have you waited?" asked Brett.

"Twenty-one" was Leone's quick answer.

An apparently sympathetic Jefferson County Court attendant overheard the friendly exchange and quickly piped in: "It's a terrible thing the way they kept that boy locked up."

Bail was set at $75,000, an unreachable figure for Leone, keeping him confined to the Jefferson County Jail until such time as the case would go to trial.

Leone, who at thirty-eight was no boy, was about to stand trial on three counts of first-degree murder. He waited under a guard's watchful eye as a panel of prospective jurors gathered in the second-floor courtroom. It had been 651 days since state police had arrested him on allegations that he and an accomplice had executed Peter Egan; Egan's wife, Barbara; and his brother, Gerald, at a rest area along Interstate 81, just north of Watertown, on New Year's Eve 1964. And it had been 607 days since a county grand jury had concurred with state police findings by indicting Leone—and only Leone—on the three murder counts.

The upcoming trial was perhaps to be the highest-profile case to be aired in this building since it was erected in 1862 at the corner of Arsenal and Sherman

Streets in Watertown. Only the trial of Mary Farmer, who had killed her neighbor Sarah Brennan near Brownville with a hatchet and had hidden the victim's remains in a trunk, might overshadow this case. Farmer was sentenced to death in the electric chair after a jury found her guilty of murder in 1908. She was the second woman to be executed in New York State.

The grand jury indictment issued on May 8, 1968, excluded from prosecution Willard Belcher, who earlier had been named in a warrant for first-degree murder, and his wife, Bertha, who was cited with being an accessory to murder. District Attorney William J. McClusky explained to reporters that the grand jury determined there was insufficient evidence to continue the charges against the couple.

Late in May 1968, McClusky said he was prepared to move the case for trial, but attorney Paul R. Shanahan of Syracuse was granted a delay because he was involved in a murder trial in Oswego County and needed time to prepare his defense of

William J. McClusky, Jefferson County district attorney and Leone's prosecutor.

The Long Wait

Leone. That was only the first delay, however. McClusky was likely not surprised when Shanahan filed a motion to suppress evidence gained from statements Leone had allegedly made to state police during the early stages of their investigation and from eavesdropping and wiretaps conducted by state police. The Shanahan motion revealed that there were two wiretaps—the one at the Belcher home and a second on the phone of JoAnne Weston, a "friend" of James Pickett.

McClusky, meanwhile, also wanted to suppress some evidence that might help the defense: Leone's lie detector results.

Two suppression hearings, both closed to the public, were held before county judge Milton A. Wiltse, and at one of those sessions, McClusky reached out to a nationally prominent champion of criminal defendants, attorney F. Lee Bailey, to be a witness for the prosecution. Bailey had won an acquittal in the retrial of Dr. Samuel H. Sheppard, charged with murdering his wife in Boston, and he had defended Albert H. DeSalvo, the self-professed Boston strangler.

Bailey was paid $3,000 to come to Watertown, the *Watertown Times*

Top: Attorney Paul Shanahan, of Syracuse, represented Leone in his trial.

Right: Jefferson County judge Milton A. Wiltse presided at the Leone trial.

Nationally prominent defense attorney F. Lee Bailey testified for the prosecution at a hearing where key evidence against Leone was quashed by the courts.

reported, and arrived on August 28, 1968, in his twin-engine Lear jet. The lawyer's role—along with those of three other witnesses, Cleve Backster, creator of the Backster School of Lie Detection, New York City; William J. Yankee, former detective and dean of Delta Junior College, University Center, Michigan; and Lynn Marcy, of Detroit, former associate of John Reid and a polygraph expert—was to share expertise about the lie detector test.

Judge Wiltse granted the motions to suppress certain evidence, including the eavesdropping and wiretap evidence. The ruling stripped McClusky of much of his ammunition for prosecuting Leone. The prosecutor's only alternative was to ask the state's highest court, the court of appeals, to consider the issue. Hence, a longer wait for Leone.

During the twenty-one months from the day of his arrest that he spent in jail, history was being made. The nation was torn over its involvement in Vietnam. President Lyndon B. Johnson decided not to seek reelection. Senator Robert F. Kennedy and civil rights leader Martin Luther King Jr. were assassinated. Apollo space missions led to the United States landing craft on the moon, with four astronauts setting foot on the moon: Neil Armstrong and Buzz Aldrin on July 20, 1969, and Charles "Pete" Conrad and Alan Bean on November 19, 1969.

And Richard M. Nixon was elected president.

On the homefront, Leone's divorce from his second wife, Anita, was finalized in 1969.

Finally, on December 11, 1969, a ruling by the court of appeals cleared the way for trial.

The high court noted testimony by expert witnesses who appeared before Judge Wiltse. Attorney Bailey said that people who work with polygraphs regard them as reliable and that he uses the machine while interviewing prospective clients. Mr. Yankee, a psychologist, testified that physical or psychological threats might cause the autonomic nervous system to react, and the polygraph measures this reaction. Mr. Marcy, a private polygraph examiner, indicated that qualified examiners will always agree on a test result, but he admitted that there are no definite standards for polygraph examiners. Mr. Backster, a polygraph instructor, described what the graph taken from the machine indicates, and state police senior investigator Bruce Martinet, who administered the Leone test, described the five-part test procedure. He also testified that the polygraph recorded Leone's emotional disturbance or stress, and he interpreted this as being due to any of three options: Leone was "practicing deception," was lying in his response or was withholding information.

The court determined that an analysis of the polygraph test administered to Leone and its results "clearly indicate that the prosecution failed to meet the standard set by this court to show a general scientific recognition that the polygraph possesses efficacy."

The judges observed that testimony had not adequately established the reliability of the polygraph or "that the examiner's opinion demonstrates reasonable certainty as to the accuracy of the polygraph test in most instances." They concluded, "We are all aware of the tremendous weight which such tests would necessarily have in the mind of a jury. Thus we should be most careful in admitting into evidence the results of such tests unless their reasonable accuracy in general scientific acceptance are clearly recognized."

McClusky, who at thirty-four had been a member of the state bar for eight and a half years, once again moved the case for trial on December 31, 1969. A prosecutor for seven years, the last four as the county's district attorney, he had a tough fight ahead now that Shanahan had succeeded in trimming the state's evidence. As for Shanahan, his challenge was to make sure his client would not be convicted of capital murder. Since the Egan trio had been slain prior to September 30, 1967, when a new state penal law became effective, Leone could be sentenced to death if convicted of first-degree murder.

FIFTY JEFFERSON COUNTY RESIDENTS were summoned to county court for the first round of voir dire by the prosecuting and defense attorneys. Although there is no available record of what questions were posed, panel members were likely asked if they had followed media coverage of the murders and investigation, if they had formed any opinions about the guilt or innocence of the defendant, whether they had any conscience issues with the death penalty or if they had any type of acquaintance with Leone or the attorneys in the case.

If they were outnumbered in a vote of guilt or innocence, could they stick to their opinions despite pressure from the majority? Would their means of making a living bring hardship by serving on the jury? Were they in any manner associated with police officers, and would they likely give a police officer's testimony more credence than that of another witness or the defendant?

Curiously, the response to the latter question, if posed, apparently did not faze Leone, Shanahan or McClusky. The eighth juror, seated on the third day of voir dire, was William G. Fletcher, thirty-three, who was a former member of the Watertown Police Department. In fact, he was a cop when his department was being frustrated by the series of Egan

burglaries, and he was still on the job when the murders occurred. Leaving the force in July 1967, he was in his new career of selling insurance when placed on the jury. By luck of the draw, Mr. Fletcher inherited the responsibility of jury foreman.

It took five days, going into the following week after a snowstorm forced cancellation of proceedings on January 9, to seat a jury of 9 men and 3 women, plus 3 alternates. Commissioner of jurors Wilma G. Baker had in the meantime called in 100 more candidates for jury duty, and the two lawyers had considered 108 people to fill the 15 slots. Shanahan exercised twenty-nine of his thirty allotted challenges, and McClusky used twenty-five.

On day seven, after the barristers' opening statements, it became necessary for Judge Wiltse to advance one of the alternates into the jury box. The second juror to have been sworn, Richard F. Coughlin, of Watertown, an engineer with the New York Telephone Company, asked to be excused "for good and sufficient reason," Judge Wiltse announced. Appointed to fill seat two was Richard H. March, of Evans Mills. At the age of forty-five, he was the father of two, an army veteran, a career truck driver and a volunteer firefighter.

Filling out the panel on Tuesday, January 13, were:

Charles A. Gregory, sixty, Watertown, a carpenter and father of five
Roy A. Franklin, sixty-three, Watertown, a salesman who had a son who would die seven years later
Thelma M. Pardy, sixty, Watertown, a food service worker and widowed mother of four
Gordon H. Anthony, seventy, Watertown, a retired state Department of Transportation highway engineer
Ambrose J. Gaffney, fifty-two, Watertown, employed with the Internal Revenue Service, father of two sons and eventual member of the Watertown City Council
Norman P. Seymour Jr., twenty-nine, Clayton, an employee of Graphic Control company
Elburtis W. "Buster" Barbur, fifty-eight, Black River, an army veteran, father of two girls and a foster daughter, asphalt company employee and eventual Town of Rutland councilman
Alice O. Petroske, fifty-two, Watertown, a mother of two boys, hairdresser and homemaker with several skills and hobbies.
Royal P. Nichols, sixty, Watertown, a district supervisor of the gas division, Niagara Mohawk Power Corporation, and father of two girls

The Jefferson County Egan Murders

Lucinda Kathryn Smith, fifty-four, Woodville, a divorcée who was a self-employed cosmetologist operating a beauty parlor in Belleville

Remaining as alternates were Robert K. Cornwall, twenty-four, of Sackets Harbor, a civil engineer with the state Department of Transportation, the father of a son and a daughter, and Dorothy Kachmar Suchs, thirty-seven, of Watertown, a housewife with a son and a daughter.

BARBARA EGAN COULD HAVE survived the New Year's Eve bloodbath, McClusky revealed in his ten-minute opening statement to the jury.

"The killers ran Barbara off," he said, "but she returned." And upon her return, "Barbara Egan knew death was coming," he said, and she tried to run. "Leone chased her, caught her, and she was thrown to the ground. Barbara Egan put her arms around Leone's knee and begged for her life. That's when Leone shot her in the head."

James Pickett, in the interview shortly before his death forty-three years later, explained that after the rendezvous took place at the rest area, Barbara was "sent away" in the Mercury Comet that Leone, accompanied by Willard Belcher, had driven to the scene. The car was owned by Beth Johnson, Leone's girlfriend. Barbara drove from the rest area, stayed away for about ten to fifteen minutes and then returned to discover what had occurred, Pickett said.

Leone and his accomplice "intended, premeditated and deliberated" the murders, McClusky told the jurors, adding that a third person had threatened the lives of the Egan brothers if they did not come up with the $1,000 they had stolen in a burglary.

"They died without much struggle," McClusky continued while telling of the scheme to get the Egan brothers—primarily Peter—to the rest area with the ruse of robbing a liquor truck. He said Leone planned the murders.

McClusky placed the time of the shootings at between 6:30 and 7:30 p.m., positioning himself for perhaps some embarrassment when he would later be corrected by one of his own witnesses.

As Shanahan took his place in front of the panel, he countered that the district attorney's "theory" had "no factual background." Leone was not at the scene, and over the years, the accused man had little interest in the case. "The defense will show that Joe Leone was not at the rest area," Shanahan asserted. "Joe was here in this city at the time."

The killings were "more of a gangland vengeance killing," he said.

Security was tight as the court readied for testimony. On any given day, at least ten sheriff's deputies were positioned at various points in the

The Long Wait

Joe Leone is escorted to another day in court.

courthouse, and as soon as the gallery was filled, nobody—except involved personnel, witnesses and reporters—was allowed entry to the building.

Watertown Times reporter Jim Brett had covered the murders and had followed developments in the case up to when arrests were finally made. The baton had now passed from him. Trial coverage belonged to Robert

Jefferson County Courthouse.

Spath. Brett was occasionally in the courtroom, however. Perhaps he was assigned to assist Spath, or perhaps he was more of a spectator, joining about 145 or more observers who crammed the room, outfitted with thirty folding chairs to supplement the fixed seats that accommodated the unusual daily turnout. Many people who had lined the sidewalk of Arsenal Street hoping for admission, even on the coldest of January days, were turned away. Among the spectators was Leona M. Egan, mother of the slain brothers.

Brett made use of his presence by descriptively setting the scene for the newspaper's readers:

The Long Wait

Reporter Jim Brett.

Lean and pale, Leone sits quietly beside his attorney. There is little conversation between the two men. Leone listens intently to witnesses, but shows little expression as he sits much of the time slightly turned in his chair, leaning on his right elbow.

[Shanahan, the defense attorney, is] *a lean, sad-eyed man, who could be mistaken for a college professor, until he swoops down hawk-like upon a witness.*

[The prosecutor, McClusky, is] *brisk, correct in his manner… is all business. Unsmiling in the courtroom, he never glances at Leone, who is seated only a few feet away. In moments of relaxation the youthful prosecutor is at times almost boyish in appearance. He sometimes reminds one of the young Mickey Rooney as he earnestly fights for his case. His is the tougher fight, for the burden of proof rests on the prosecution.*

And then there is the key prosecution witness, as observed by Brett: "In a word, nervous; his eyes rimmed with lines, it is an uneasy James H. Pickett who is called to the witness stand to turn state's evidence…Pickett seems to avoid looking at Leone, who stares intently at him."

Pickett appeared nervous, accentuated by his low tones as he responded to questions, Bob Spath reported. McClusky grew frustrated with him, accusing him of having a "fuzzy memory" when asked for certain times and conversations leading up to the murders and the days that followed. But he managed to tell the jury that Leone told him "two or three weeks before Christmas [1964]" at the Red Moon Diner that the Egan brothers had to die. "He had to do away with them on account of that they were going to be picked up and tell everything and involve us all. The Egans had to be terminated before they talked."

And then, four or five days after New Year's Day, "Leone told me he and Willard Belcher shot the Egans," Pickett testified.

Pickett said he had been recruited to play a role in the murder scheme, to drive a truck supposedly carrying liquor to the rest area. He said he declined, explaining that he had company at home, his mother-in-law. He added that as the plan was discussed, he did not believe that Leone, his longtime friend, would actually carry it out.

Shanahan brought up Pickett's arrest on March 25, 1968, when state police cited him with withholding information in a murder investigation:

> *Shanahan: Was that dismissed in consideration of signing an affidavit regarding your testimony here today and in connection with all the burglaries…the whole works…everything you have ever done?*
> *Pickett's tongue-in-cheek answer: Must be.*
> *Shanahan: When you found out you could get out of everything you ever did? That's when you agreed to say everything they wanted you to say, is that right?*
> *Pickett: No.*

Shanahan then alluded to a comment in McClusky's opening about a death threat against an Egan in lieu of the return of stolen property. Had Pickett discussed the "Gonoski threat" with Leone, Shanahan asked.

"Yes," the witness replied. In the conversation before Christmas at the Red Moon Diner, "he [Leone] asked me if I heard about it and I said 'yes,'" Pickett confirmed.

In his recent interview, Pickett said it was known to several people, including the Egans, that Joseph Gonoski, also spelled Gonsieski, had made a death threat against an Egan because of the theft of cash from a safe in his pool hall on Public Square. Gonoski, who was known to have been a spectator in the courtroom, was not called as a witness by either attorney, but Shanahan would not forget about him later in the trial.

McClusky called Rotary Gas station attendant Richard Woods to the witness stand to help lay out the last sightings of the Egans on the afternoon and eve of their murders. And it was here that the prosecutor found himself being contradicted. Woods said he had seen the brothers as late as 7:30 p.m., after they had made their last gasoline purchase. McClusky's opening statement had them dead by 7:30 p.m.

The time Woods gave for that gas purchase also contradicted information police were given in the early stages of their investigation. Woods said the Egans made two-dollar gas purchases at the Rotary station at about 6:00 p.m. and again shortly before 7:30 p.m., whereas revelations by police in

The Long Wait

January 1965 had the Egans making their second gas purchase at Green's Gas on Bradley Street, also shortly before 7:30 p.m.

Woods also said he saw Leone with the Egans and others when he arrived at about 4:45 p.m. for his work shift at the Rotary station. Barbara Egan, accompanied by two children, drove away from the station at about 6:00 p.m., he testified.

Woods revealed that during the course of the investigation, state police had questioned him up to six times. He was uncertain about the exact number of interview sessions.

Regarding the alleged Gonoski threat, Woods told how Peter had verbalized his death premonition—"Tonight's my last night"—as he played a pinball machine.

"Everyone at the station knew a threat had been made against Peter," he testified.

"Was the threat made by Gonoski?" Shanahan asked.

"Yes," Woods responded.

Woods also said he heard Peter comment, "I am running the show, not Leone," and then said that he would be returning by 10:00 p.m.

Also among the prosecution's witnesses were:

William Jay, to tell how he discovered the murders at about 9:30 p.m.

Trooper C. David Hudson, who described the bloody scene he found upon responding at 9:45 p.m.

Sergeant Robert VanBenschoten, who testified to the accuracy of photographs being presented for evidence that he took at the murder scene.

State police investigator William H. Anderson, of Rome, New York, whose only mission at the trial was to confirm that he had witnessed the autopsies of the Egans on New Year's Day 1965.

State police sergeant William J. Gary, a firearms examiner who said remnants of .38- and .25-caliber bullets were found at the scene, that he believed all six .38-caliber shells were fired from the same gun and that he believed two guns were used in the slayings.

Robert J. McKinley, a state police chemist, who talked of his findings in the victims' car and revealed that Barbara Egan's natural black hair had been dyed brown.

Captain Jerome J. McNulty, state police senior investigator at the murder scene, who said the shootings occurred on a clear but bitter cold evening. There had been no snowfall, and there was no snow on the ground, he said. He also identified death scene evidence, including shells and discharged bullets.

Shanahan was more interested in the alleged death threat, asking McNulty if such a threat had been made by a Joseph Gonoski against Peter Egan.

"Yes," the captain replied.

"Threats against the Egans, effective by December 31, 1964?" Shanahan shot back.

"Yes," said McNulty.

As that line of questioning continued, McNulty revealed that Gonoski and Peter Egan had been involved in gambling.

Shanahan asked if Peter Egan was involved in narcotics trafficking.

"Not to my knowledge," McNulty answered.

Dr. Richard S. Lee, who performed the autopsies, described his findings about the bullet wounds. When asked by Shanahan if "it would be impossible to tell the sequence of those wounds," Lee replied, "I would have to agree with that."

As McClusky moved to wrap up his presentation, he had—or thought he had—his "mystery witness." An unwilling witness, as it turned out. On January 16, the third day of the prosecution's case, Robert Edward Pray, thirty-two, was called to the witness stand.

Pray, from Ogdensburg, had been subpoenaed from Attica Correctional Facility, where he was serving a term for a burglary at a skeet range owned by the Pine Tree Point Club, Alexandria Bay. His arrest on October 3, 1968, prompted his confinement in the Jefferson County Jail, where, according to him, he shared a jail cell with Leone. But he had decided not to tell his story. He was angry that photographers had taken his picture while he was being escorted under police guard to a court session sometime the previous year. Prior to that occasion, state police had made a deal with Pray that his appearance and identity were not to be known—at least not until he was to have taken the witness stand—in exchange for his testimony.

"Chewing gum, with hands tucked inside his trouser belt, Pray said, 'Nope' when he was asked to take an oath on the Bible," the *Watertown Times* reported. "After a pause, he looked at the judge and said, 'Got nothing to say, your honor.'"

Judge Wiltse recessed to his chambers with the two lawyers, and then McClusky announced moments later in court that he was resting his case. The judge recessed for the weekend, allowing time for Shanahan to prepare his defense of Leone and his motions.

Come Monday, Pray had changed his mind. McClusky reopened his case for the prosecution, allowing Pray to tell the jury that Leone had confessed to him that he killed all three Egans. The alleged admission came while they were playing cards, "about the third week I was there," Pray said.

The Long Wait

"Mystery witness" Robert E. Pray was not pleased when photographers focused on him as he was escorted to testify against Leone.

Pray also said he told Leone he had met Willard Belcher in prison. Leone replied that he wasn't worried about Willard because "Willard was a certified nut and nobody would believe him," Pray testified.

Then the "hawk," as described by Brett, sprang at his prey. Shanahan forced Pray to outline his criminal past involving felony convictions over the span of a dozen years, all for theft and burglary. He had spent the majority of that time in jails and prison, the witness acknowledged. He confirmed for Shanahan that he had an application to dismiss one of those convictions pending in Wyoming County.

> *Shanahan: You have not been successful up to this point to shorten your jail term, so you are testifying against Leone in order to get some satisfaction. Would that be true?*
> *Pray: I don't think so.*

Shanahan asked why Pray had refused to testify on Friday.

"I was sick and I had to have a doctor," Pray replied. "My stomach was bad."

And what, Shanahan asked, had transpired over the weekend that helped Pray change his thinking about testifying? Had he been visited by the DA or police?

That Friday night, Pray acknowledged, he was visited at the Lewis County Jail, in Lowville, New York, where he was temporarily being held, by McClusky and state police investigator Charles Donoghue. He gave them an oral statement, which they tape recorded, he said.

After Shanahan had his shot at Pray, he asked for dismissal of the charges against Leone, arguing that there was a lack of credible evidence to corroborate the testimonies of Pray and Pickett. With his motion denied by Judge Wiltse, Shanahan's turn had come to advocate for the alleged innocence of his client. He opened with Fern Leone to serve as a character witness for her son.

Beth Johnson, who said she was in love with Joe Leone and had lived with him for six or seven years in the Central Street apartment, followed his mother to the witness stand. Shanahan used Miss Johnson to establish an alibi for Leone on the night of the murders. Joe had returned home at about 7:00 p.m. on New Year's Eve, she testified, and remained home the rest of the night.

McClusky shot a couple holes in her testimony, first by using her own words against her. In her testimony before the May 1968 term of the county grand jury, Miss Johnson had said that when Leone returned home that night, she saw spots on his jacket. "What about those spots?" the prosecutor asked.

"I meant holes," she replied. "Both the same to me."

It was left for the jury to wonder: if there were spots on the jacket, were they splatters of blood?

And when he had the option of producing a rebuttal witness, McClusky called for Investigator Donoghue to tarnish the alibi. The detective said that when he first questioned Miss Johnson in March 1968, she had told him that Leone returned home at about 8:30 p.m., while the program *My Three Sons* was showing on Watertown's television station, WCNY.

When McClusky stood face-to-face with Miss Johnson, he asked the witness, regarding her relationship with Leone, "Are you in love enough with him to lie for him?"

"I wouldn't lie," she replied.

Shanahan wrapped up his case by calling Joe Leone to the stand at 11:45 a.m. on January 19 and related his initial questions to his client's situation prior to the murders. In 1964, Leone said he had been seasonally employed, driving trucks for construction jobs, and was unemployed at the end of the year. At the time of his arrest in 1968, Leone said he had been employed by Continental Baking Company for two years.

On the day of the murders, he said he drove the 1963 Comet owned by his girlfriend, Beth Johnson, to the Red Moon Diner at about 8:00 a.m. "We went together because Beth wasn't working," he said. She then drove off, leaving him at the diner, he said.

Leone said he met with the Egan brothers at the Rotary Gas station and subsequently accompanied Peter Egan and Pickett to the diner. He was driven home at about 6:00 p.m. by his parents, he said, echoing the same account given by his mother when she testified.

The Leone testimony conflicted with earlier testimony by Richard Woods, who said he saw Leone drive from the gas station at about 6:00 p.m. in Beth Johnson's car.

"Beth started supper, and I cleaned up," Leone continued. At about 6:30 p.m., he left the house to buy a pint of whiskey and a pack of cigarettes at a store about four blocks from home, he said, and was back at the house at about 7:00 p.m.

> *Shanahan: Did you participate in any way in the deaths of the Egans?*
> *Leone: No, sir, I did not.*
> *Shanahan: Did you see the Egans at any time after you saw them at the Rotary Gas station the night of December 31, 1964?*
> *Leone: No, sir, I did not.*

> *Shanahan: Were you at the rest area that night?*
> *Leone: No, sir.*

As the questioning continued, Leone said he had first heard of the murders on the morning of January 1 at Red Moon Diner, when he and his girlfriend, Beth Johnson, met with Pickett.

Regarding Pray, he said he recalled seeing the inmate in jail in March 1968 but denied having any conversation with him. He said he never discussed the case while confined in the "grand jury section of the jail."

However, during cross-examination by McClusky, Leone admitted that he had a short chat with Pray in jail. "Pray said he had seen Belcher in prison, but he didn't say what prison," Leone said.

> *McClusky: Didn't you say you didn't have to worry about Belcher because he was a nut?*
> *Leone: No.*

Leone also denied that he was involved in burglaries with the Egans or that he had said to a deputy sheriff that he was "going to get McClusky." But he admitted to saying, "I would like to see you walking across the street when I was driving a truck."

Newspaper coverage does not reveal any strong cross-examination attack by McClusky regarding Leone's denials in connection with the murders. Shanahan closed his defense at 12:40 p.m., which indicates that Leone's testimony lasted just shy of an hour.

Summations were given the next day. Shanahan gave a seventy-five-minute discussion about why Joe Leone should be set free, while McClusky took twenty-five minutes to pull his case together.

"There is no evidence to warrant a verdict of guilty to any crime," Shanahan asserted. The slayings were "a cold blooded execution—a gangland murder that you would read about in Brooklyn," he continued.

Leone testified that he had been at home the evening of the murders, his lawyer said, adding that the claim was supported by the woman living with him. Leone's time alone that night was narrowed by testimony to a half hour, from 6:30 to 7:00 p.m., Shanahan said.

He referred to the fogged-up windows in the death car when Mr. Jay made his grisly discovery and pointed to that as evidence that the victims were still alive shortly before Jay arrived, thus questioning the time of the shootings.

The Long Wait

He asked what had happened to testimony that the district attorney, in his opening statement, had led the jury to expect:

> *Have you heard anything in this trial about robbing a liquor truck and chasing Barbara away?...Where's the evidence?...Don't you think that if they found Joe Leone or Willard Belcher's fingerprint on that car, they would have put it into evidence?*

Shanahan challenged the veracity of two key prosecution witnesses:

> *James Pickett turned state's evidence after a felony charge against him for withholding evidence regarding the Egans' case was dismissed. Pickett got a complete dip in the River Jordan.*
>
> *Robert Pray did not testify until BCI investigator Charles Donoghue went to Lowville and talked to Pray...Pray refused to testify Thursday but changed his mind the following day.*

And he brought up the man who did not get called to testify, even though his name had come up in testimony. Pointing to a man in the crowded gallery, Shanahan asked, "Why was Gonoski not brought to the stand to testify, instead of sitting in the courtroom?

"What kind of case is this?" he challenged. "Should we commemorate Belcher in some way? The DA tells you he didn't have enough evidence to convict Belcher when he has the same evidence against Joe Leone."

Giving a final glance at the panel, Shanahan asked, "Please do the right thing. Thank you."

McClusky accused the defense attorney of trying to make "pinholes into craters" in the prosecution's case. He agreed with Shanahan's assertion that the murders were gangland hits but added, "As normally criminals kill criminals." He said the murders were done "by a cooly with a cool hand."

He reminded the jurors of Pray's testimony that Leone had admitted to him that he had killed all three Egans. Responding to Shanahan's theory about the foggy windows in the Egan car, he countered, "The fog came from body heat and the dog."

McClusky asked the jurors to remember the brutality of the events of December 31, 1964, and to also remember "that's the man who wants me in front of his truck."

Judge Wiltse adjourned for the day, delaying until the next day, Wednesday, January 21, to present his "charge" and, ultimately, the case to the jurors. Certainly, he did not anticipate that he was giving somebody some time to dabble in jury tampering.

On that Tuesday afternoon and evening, phone calls were made to the homes of four jurors. One juror and the wives of three others picked up their phones to hear a male caller's voice, speaking in a foreign accent, say, "If Joe Leone is found guilty, you are dead."

The first order of business the next morning was for Judge Wiltse to question the twelve jurors and two alternates individually in his chambers. Reporters were not told the reasoning behind the forty-minute process until two days later. State police would investigate, but the identity of the caller was never determined.

In any event, Judge Wiltse was convinced the panelists were not influenced by the threat. The twelve who sat in the jury box would in the end be the deciders of Joe Leone's fate.

A judge's "charge" to the jury consists of explanations about the specific accusations, meanings of phrases in the state penal law, boundaries set in criminal procedure law and what elements of testimony and evidence presented in court should or should not be considered when the jury weighs the pros and cons of a defendant's guilt or innocence. Judge Wiltse took eighty-one minutes in his advisory to the jury.

Finally, at 3:45 p.m., the jury was sent out of the courtroom to commence deliberations. It didn't take long—just one hour and fifty-five minutes.

Shanahan was hopeful. He said he thought "it would be a favorable verdict because it had been recorded that fast. But you never know."

Leone showed for the first time a sign of nervousness, *Watertown Times* writer Bob Spath reported, as jury foreman William Fletcher stood to announce the verdict.

To each count of first-degree murder, the jury found Joe Leone "not guilty."

Leone turned to Shanahan, and they shook hands while those in the gallery, their numbers now reduced to twenty-two, let out sighs of relief. Leone then rushed over to Beth Johnson, who was in tears, and embraced and kissed her. Then he turned to his mother and hugged her, then his sister and, lastly, shook hands with his father.

Beth joined Leone, and he walked out of the courtroom, a free man for the first time in one year and 302 days.

His vote for innocence occurred on the jury's second ballot, it was later revealed. The first count had been eleven to one, also in Leone's favor.

The Long Wait

The courtroom where a jury of nine men and three women acquitted Joe Leone.

Free at last, Joe Leone is joined following his acquittal by his parents, Anthony and Fern Leone, and his future wife, Beth Johnson.

As the courtroom cleared, Bill McClusky sat stunned and quiet at the prosecutor's table, possibly wondering what he could have done differently to deal with the loss of evidence stripped away by higher courts. Had he failed to lay out all the evidence that was at hand? Had he forgotten to bring out testimony regarding his opening statement assertions? Had he gone too easy in his cross-examination of Joe Leone? How had he failed to give a convincing summation?

A day later, he commented that he was surprised the jury did not deliberate longer.

"At least twelve people in Jefferson County believe he's not guilty," he said.

Many years later, after he had advanced to the position of county judge and subsequently opened his private practice with two sons, he told a reporter that losing the Leone case was his biggest disappointment. He had a couple other high-profile cases during his tenure of about seven years as district attorney. There was his decision to settle for a guilty manslaughter plea from the killer of two children, Arthur J. Shawcross, who would become a serial killer of women. And then came the murder that he never had a chance to prosecute because nobody was charged in the bludgeoning death of Irene Izak on June 10, 1968, on Wellesley Island, near the Canadian border. One of the last places where she was seen alive was at the same rest area where the three Egans were slain, just north of Watertown.

Chapter 5

DAUGHTER: PICKETT LIED

After three years, two months and twenty-three days of investigating the Egan triple homicide, state police finally arrested a man they had been looking at since day one. James H. Pickett was not their triggerman, they believed, but he could provide the "major break" needed to bring down arrests.

And he did.

But could this man who was turning state's evidence be trusted? Could he be believed?

In one word, no, says Pickett's eldest daughter, who in July 2014 broke nearly a half century of silence to disclose that he might have lied to police about his whereabouts on the night of the murders. He might have lied about it under oath in front of a trial jury and apparently to a grand jury. And most recently, he lied about it to an author of this book, according to the daughter, who will be identified only by her given name, JoAnn, to protect her present-day status and family. She said she believes her father, James Pickett, was near the scene of the Peter and Gerald Egan killings and likely witnessed the murder of Barbara Egan.

And she has lived for the past fifty years wondering if indeed her father had one of the Egans' blood on his hands. His incriminating lie, JoAnn told co-author Daniel T. Boyer, was his alibi.

Pickett said he was asked to drive a truck to the rest area off Interstate 81, north of Watertown's Bradley Street exit, to give the appearance that he was transporting a load of liquor. The Egans were told the truck was

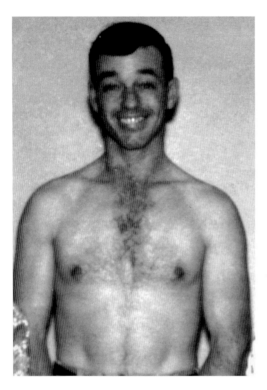

James Pickett, key witness against Joe Leone, lied about his alibi on the night of the Egan murders, according to his daughter. *Courtesy of his daughter JoAnn.*

to be hijacked. Pickett said he backed out of the scheme, explaining he needed to be home because his mother-in-law was at his house for the holiday.

Indeed, Ann Royko, the mother of his wife, Dolores Pickett, was visiting from Baltimore, Maryland, JoAnn confirmed.

"My father went out that night, and he never came home until past midnight," JoAnn said. "There's no doubt in my mind. I was twelve, and I remember. I know my father was there that night."

She then asked Boyer, "Can you tell me if he did any of the shooting? That's always bothered me, not knowing."

She was told Pickett's comment to Boyer: "I couldn't kill anybody. Could you?"

"For all these years, I thought my father may have done it," the daughter said. "I knew he was at the scene. That's a relief knowing he didn't kill those people."

Her father never discussed with her the events of that night, but he might have filled in his wife, Dolores. JoAnn said she gathered all the information that she had about the murders from her grandmother and her mother and was told that Pickett was instructed by Leone to "take Barbara out of here."

So Pickett might have accompanied Barbara in leaving the rest area, either walking or in a car. Then she heard gunshots, turned back and ran to the death scene, according to what JoAnn said she was told.

Leone apparently fired three .38-caliber shots from the backseat of the car through the windshield, aiming at Barbara. He then ran toward her, chased her and, as police surmised, flung her to the ground by her hair, stomped on her head and neck and shot her.

The .38-caliber murder weapon had been stolen in a burglary, according to Pickett.

How did police know that Barbara was sent away before the shooting started? How did police know that Leone chased her, dragged her by the hair and stomped on her neck? Was it by physical evidence, such as loose strands of hair, or was it by pathological evidence? Or did police have a witness, a guy by the name of Pickett? Why else would police have known that Barbara had wrapped her arms around Leone's knee, pleading for her life? Certainly by the time police arrested Leone, thirty-eight months after the fact, they could not have recovered the slacks Leone wore on that bloody night in order to inspect them for traces of a struggle.

It should be noted here that court transcripts and police investigative reports are sealed in accordance with New York State law because the case was closed without a conviction. Hence, the public can only speculate about what happened that night, with knowledge limited to what appeared in the pages of the *Watertown Daily Times*, the *Syracuse Post-Standard* and any newspapers that carried shortened versions offered by press wire services.

The Pickett name never came up publicly in the murder investigation until his arrest on March 23, 1968, when he was accused of withholding information in a homicide investigation. District Attorney William McClusky told reporters that Pickett had been questioned for "a couple days" before his arrest.

JoAnn said police questioned her mother and grandmother, but she does not know what the investigators learned from them. Perhaps they destroyed his alibi, prompting his arrest.

Police were actually "on" to Pickett on New Year's Day, according to JoAnn. Police were "swarming" all around the Pickett house at 540 Bradley Street the day after the murders, she said, with round-the-clock surveillance of the home continuing for several days.

Knowing that Pickett had lied about being home for New Year's Eve and seeing all the police presence out on the street, Dolores Pickett and her mother strongly suspected that he was somehow involved in the murders, JoAnn said.

JoAnn also may have an answer to another mystery surrounding the events of New Year's Eve 1964. She said she believes the dark blue car seen that evening on Bradley Street, where an occupant of the vehicle was talking to the Egans, was owned by her father's girlfriend, Joanne Weston.

The Pickett family had been living on Bradley Street for at least four years when the murders occurred. Her father, Joe Leone and Phil Marra were

best friends, JoAnn said. They hung around the stock car crowd. Leone was a frequent guest in the Pickett home and was very friendly and personable, she said.

Loot from the Egan-Leone-Pickett burglary syndicate was brought into the garage at the Pickett residence, she recalled. There, the loot was split up and stored in taped boxes.

"No way" was Mr. Marra involved in the murder or the group's crime wave, she said.

Her revelation about Joanne Weston led to a discussion about her father's open infidelity. He was married to Dolores and living under the same roof with her, but he was openly seeing Weston and had a child with her—his second James Pickett Jr., JoAnn said.

While having her affair with Pickett, Joanne Weston, who was eleven years younger than Dolores, often drove by the Pickett home, JoAnn said. If she saw JoAnn and her brother and sister outdoors waiting for their school bus, she would stick her tongue out at them.

And while Pickett was having that double life, he was also having relations with several other women, JoAnn alleged. One of those, she said, was a woman for whom JoAnn was babysitting. That woman bragged about it and boasted about when she was going to have sex again with her father, JoAnn said.

Dolores Pickett was fully aware of her husband's extramarital activity, she said. "My mother had a nervous breakdown and suffered from anxiety attacks often." Dolores battled depression all her life and was prescribed large quantities of Valium. She also lived in fear after the murders, thinking that she and her family were going to be the next victims.

And with good reason, according to Larry Corbett, a friend of the family. "After the murders and the subsequent investigation, she and her husband received many threats, in person and by anonymous phone calls," Corbett said. Curtains were always closed, and the doors were always locked.

"She never trusted anybody after that," JoAnn said.

Prior to the murders, the Pickett home had been burglarized once, she said. They never knew who did it, but they suspected the Egans.

JoAnn spoke openly about an even darker side of life in the Pickett home.

"My father sexually molested me from the ages twelve to eighteen," she revealed. "The molesting only stopped because I moved away from home.

"I lived in shame for years because of this and never told anybody until I was an adult and had my baby. I don't want anybody else to have to go through that. It's important to talk about the sexual abuse so no other little girls have to live their life in shame."

Daughter: Pickett Lied

She said she was very afraid of her father "because he constantly threatened me." Once when he got angry with her, he threatened "to cut my face up" with a knife. "I'll make you ugly and nobody will ever want you," she quoted him as saying.

Because of all the sexual abuse she endured in her childhood, she said she finds it difficult to be in a room alone with a man, any man. She works at a bank and said that even though she is sixty-two, "I still have issues trusting men because of my father."

After moving out of the family home at age eighteen and getting a job, she said she looked around and found a place in Watertown for her mother and younger sister to live, to make sure he didn't molest her sister. The family home at that time was in Depauville.

Her brother, the first James Jr., was familiar with a different kind of abuse from their father, she said. "He beat up Jimmy with a belt all the time, frequently and excessively," she said. Jimmy always acted out because he was neglected all his childhood, she said.

"He would do crazy things, get in trouble just for attention, and then our father would beat him excessively with the belt."

Her abused brother lived to be fifty, passing on June 21, 2004, after he suffered a heart attack in Rochester.

As for Dolores, who divorced Pickett in 1976, "she knew all along about the sexual molestations when I was a kid and never did anything about it," JoAnn said. "She allowed it to happen."

After learning of her mother's awareness, JoAnn said she did not speak to Dolores for the last six years of her life. Dolores Pickett died at age sixty-nine on April 29, 2000.

JoAnn said she always dreaded being asked for her maiden name, feeling so humiliated by her disgraceful father.

After returning a phone call from co-author Boyer when writing for this book was nearing completion, JoAnn said their conversation "made me talk about something that I hadn't thought of in a very long time." She became open about it because "I want people to know he wasn't a good man as he had some think."

Despite her feelings toward James Pickett, when she gave birth to a girl, his first grandchild, she brought the baby into the home he shared with his second wife, Joanne Weston Pickett. They were married in the same year of his divorce. She did not permit him to hold the infant, however, JoAnn said, because of all the molesting she had endured from him.

"I didn't trust him and didn't want him molesting my daughter."

She made a few more visits, and then, she says, "I just stopped going. I wasn't comfortable." For about thirty years, she did not see her father or his second wife again—until one day she unexpectedly met him at the Northern Federal Credit Union on Factory Street.

"I began to shake and was very nervous," she said. "I just wanted to go in and do my banking and leave. He began to tell his workers I was his daughter, and my reply was, 'No, I am not,' and I walked past him." He was foreman of a paving crew that was resurfacing the parking lot at the credit union.

She never saw him again.

James Pickett, in a two-hour telephone interview with Boyer on March 2, 2013, actually claimed he had forgotten all about the murder case. "It was a fascinating case," he said. Knowing that he was dying, he said he was enjoying talking about it.

"I never talked about it with anyone. In fact, I haven't even thought about it for forty years, not until you called me," he said.

Never during the conversation did he say the first names of the Egans. He referred to Barbara as "she" or "her," to Peter by his last name and to Gerald as "Young Egan." It was as if he had blotted them out from his memory.

"She came from a good family and was a pretty girl when she was younger," he said. "She was real nasty and dirty after Egan got a hold of her."

Pickett, a widower since the death of Joanne Weston Pickett in 2011, claimed he was unaware of the murders until hearing about them in a late-night television bulletin on New Year's Eve.

Later on the same day of his telephone interview with Boyer, eighty-one-year-old Pickett was admitted to the Samaritan Medical Center in Watertown. He never returned to his home in Limerick, dying on April 15, 2013.

EPILOGUE

"You better make your payments on time or you may end up out on 81."
But it was with a wink of the eye that Joseph R. Leone made this comment as he sealed the deal in selling a car to a sixteen-year-old girl, Yvonne Parker-Hook. He was joking, according to her mother, Sharon Prosser Hook-Pfuntner.

Seven years had passed since Leone had beat a murder rap in Jefferson County Court. He was working for Granger Paving, with one of his bosses being Sharon's husband, John Granger.

"Joe worked at Granger Paving because he was a good worker and a friend of John's," Sharon said. "He worked for my ex-husband [John] for several years."

Beth Johnson and Leone occasionally stopped in at the John Granger home for dinner, and "John and I went there [to Leone's house] a few times, also," she said.

"He was always nice to my kids and myself. He was quiet and kept to himself. After he came home from jail, I guess the questions never stopped, and he felt like he was still being singled out." She added, "He never said if he was guilty or not. He never seemed violent to me, but after all that mess, he was different."

Beth had remained a tenant in the Amedeo house on Central Street during Leone's incarceration, and while she continued to be friendly, she did not discuss the case, Joe Amedeo said. Following the acquittal, the couple continued residing there for a while, he said.

Epilogue

They eventually moved to 309 Logan Street, their apparent last Watertown address. By 1981, Leone had taken a bartending job at the Hitchin Post Tavern on Court Street, familiar digs from the days prior to the murders.

Meanwhile, there were occasional reminders about the murders, assurances to the couple that as long as they lived in Jefferson County, they would be living under that cloud. For instance, there was the evening in about 1972 or 1973 when two city cops took their break in the Red Moon Diner. The senior officer, about sixteen years older than his rookie partner, saw Joe Leone.

"Hey, Joe!" the senior man shouted. "Have you shot anybody today?"

"Nope, not today," a smiling Leone responded.

The now-retired "rookie" who recalls that encounter said, "I almost fell out of my seat" when his partner posed the question.

The couple left Watertown about 1982, relocating to Hannah, South Carolina. Leone obtained employment as a truck driver with a food distribution business and Rocket Express, a national trucking company.

By the time he died from complications of cancer on November 7, 2003, at the age of seventy-two, Leone and Beth had married. His obituary in the Charleston, South Carolina *Post and Courier* indicated that he was an army veteran and an American Legion member and enjoyed bowling and playing pool and pinochle. At this writing, Beth Johnson Leone is said to still be alive.

Before Joe Leone went to trial, the *Watertown Daily Times* calculated what his incarceration from the day of his arrest had cost the taxpayers of Jefferson County. Brought up to the day of his acquittal, the cost of $5 per day placed his jailing tab at approximately $3,335.

"All in the neighborhood" might be an appropriate description for many of the individuals involved in the Egan story. When immigrants from Italy settled in Watertown, a majority made their homes in an area called "the flats" along Arsenal Street and adjoining roads. Today, Arsenal Street is a main artery in Watertown.

Among the intersecting streets are Duffy and Dorsey, both dead ends, separated by one block of Arsenal. The longtime home for the Egan brothers and Leona Fober Egan was on Duffy, while two doors away lived the Anthony Leone family. That dwelling, at this writing, remains a Leone residence.

Also still in the Leone family is a house on Dorsey Street, once the home of Joseph and Anita Leone.

Seven blocks to the east on Arsenal Street, Sherman Street is situated. There, newlyweds James and Dolores Pickett resided briefly after he

Epilogue

concluded his military career. They moved in about 1959 across the Black River to Bradley Street on the north side of Watertown. That made James Pickett an across-the-street neighbor of Richard Woods, fellow prosecution witness.

Not long before the Leone trial, Woods moved onto High Street, becoming the across-the-street neighbor of Willard and Bertha Belcher. High Street is south of the Black River, approximately at the center of the city, intersecting with State Street, another major artery. Joe Leone, at the time of the murders, was living on Central Street, another offshoot from State Street, two streets away from the Belcher house.

Bertha Montondo Belcher had no fear and was not afraid to express herself, even after being accused of being an accessory to three murders. If she felt the public needed to hear her opinion, she let it out in the same newspaper that had reported about her alleged misdeeds for decades, the *Watertown Daily Times*. Her first offering, as far as can be determined, occupied the letters column in February 1974, when, complaining about city snow removal ordinances, she challenged Mayor Ted Rand to shovel "around the fire hydrants."

She was inspired in May 1975 to complain about the United States spending millions of dollars by bringing refugees to this country. "Keep the money home, where we need it," she asserted.

It took only one paragraph for her to say thanks, for undisclosed reasons, to "our faithful friend" Jim Brett in September 1977. Unknown is whether she was speaking about the former *Times* reporter James C. Brett or local politician James E. Brett, who at the time was a member of the Watertown City Council. "God bless you, Jim," she wrote.

Bertha penned two letters in July 1978. First came her criticism for the City of Watertown's decision to place a traffic light at Factory Square, where four streets come together at peculiar angles. She had lived there for thirty-four years, she said, and the new lights "tie up traffic more than before they were installed."

Later in the month, she was provoked by a letter writer who had complained about people who have children living near a hostel. She asked, "Who are you to say where the children can live?" And then she put the other writer on notice, claiming that he or she was "sick…in the head."

She liked Dr. Chris Ronson of Watertown, letting it be known in two letters. She commended him in January 1980 for being dedicated and caring and labeled as "junkies" those people who "are trying to ruin our good doctor's name." She followed in April 1981 by praising him for the medical care he had given her.

Epilogue

And Bertha was politically motivated. She advocated the election of Watertown's Wesley Eisenhauer to the county board of supervisors in November 1979 and twice wrote letters in 1984 expressing her disdain for President Ronald Reagan in his reelection bid.

"I am an old lady living alone. My Social Security helps, but I have to go without to make ends meet," she wrote in a letter appearing in February 1984. "Reagan has plenty of money to send overseas and keep all the people who come here where they don't belong. Charity begins at home."

Even for being an innocent victim, she couldn't keep her name out of newsprint. Such was the case in December 1969, when she slipped on ice and fell on Public Square, bruising her hand and knee. In September 1974, she was rendered unconscious in a two-vehicle collision on Coffeen Street in Watertown. Her car was struck in the rear after a bee flew into the face of the driver of the second auto.

There often seemed to be confusion about Bertha's age when police agencies filed charges against her. The confusion was finalized at age ninety-three, when she died on January 11, 1989, in McAuley Hall of the then Mercy Hospital. There was no funeral.

ALTHOUGH WILLARD BELCHER was placed in a state correctional facility for the criminally insane back in 1968, he was free from state custody sometime after Joe Leone won his acquittal. Records have not been retained by the New York State Department of Correctional Services and Community Supervision to reveal when and why he was discharged. He was not out of the sight of law enforcement, however. After being injured in December 1972 in an auto accident on Route 37 in Jefferson County's town of LeRay, he was charged with driving while intoxicated. He was placed in the county jail on November 18, 1973, after he was alleged to have threatened the life of McClusky, who by then had left the post of district attorney to be appointed Jefferson County judge. Police were informed about the threat by Bertha Belcher. Willard was returned to state custody and was reported to have died at age sixty-one "in an Ogdensburg hospital," likely the St. Lawrence Psychiatric Center at Ogdensburg, New York, on March 7, 1976.

Willard died in prison "because he was involved with the mob, Irish and Italian," said a granddaughter, who added that she loved her grandparents no matter what they did, "and that's not even the tip of the iceberg."

WHATEVER ARRANGEMENTS ROBERT PRAY may have gained for his assistance to the prosecution against Joe Leone did not get him out of prison. He

Epilogue

died of a heart attack in 1974 while still serving his sentence at Adirondack Correctional Treatment and Evaluation Center in Dannemora.

There is no public record of Joseph Gonoski ever being linked to the Egan deaths, only the suggestive testimony, which in itself sounded more like thirdhand hearsay. An army veteran who served in the European theater of World War II with the Tenth Armored Division, he died in May 1989 at the age of seventy-one. Anthony Leone, the father of Joe Leone, was a construction flagman when he was struck and killed by a vehicle on September 17, 1973. The accident occurred at the northbound on-ramp of Interstate 81 at Bradley Street, the same exit taken by the killers en route to the Egan executions a mile up the highway. He was sixty-four years old.

The authors and publisher have agreed not to use the names of the three Egan children. One of Barbara Egan's high school classmates said that prior to the murders, the children "were always running wild, and they were always dirty looking. And they constantly used horrible, filthy language. It's a shame nobody wanted those kids." Another classmate said the children were placed in a rehabilitation facility shortly after the murders to help them forget everything about their past.

Watertown Daily Times files show no stories about the trio in their adult years. It has been suggested that their names were changed, and they were moved out of state.

F. Lee Bailey continued to be involved in nationally prominent cases, including being lead defense attorney for Patty Hearst, daughter of *San Francisco Examiner* managing editor Randolph Hearst. After being kidnapped by the so-called Symbionese Liberation Army, she was a visible participant in robberies and was eventually charged for her role in the crimes. Brought to trial in 1976, she was convicted of armed robbery and use of a firearm during the commission of a felony and served a prison sentence.

Bailey also assisted in the successful defense of O.J. Simpson in 1994. The former professional football star was acquitted of charges that he murdered his former wife, Nicole Brown Simpson, and her boyfriend, Ronald Goldman.

Bailey was disbarred in 2001 in Florida after being found guilty on seven counts of attorney misconduct by the Florida Supreme Court. Two years later, similar action was taken in Massachusetts, and in April 2014, Maine's Supreme Court denied his application to practice law in that state.

In August 1969, Bradley Realty Corporation, which was located at 489 Newell Street, filed a $100,000 lawsuit against Jefferson County and New York State for alleged damage to three of the company's warehouses on the Black River. The company claimed that the use of underwater explosives

Epilogue

during the search for the Egan murder weapons, ordered in the spring of 1968 by McClusky, caused a portion of an old wooden dam at the south end of Newell Street to be removed. With half of the dam swept away, river water was diverted, creating a major flow of the river against the Bradley buildings, resulting in structural damage.

After Jefferson County settled out of court for $3,000, the claim against the state went to a trial in the state's court of claims in November 1974 before Judge Henry Lengyel.

The judge's review of testimony and evidence, contained in his written decision, included the following: The dam ran in a north–south line, from the Bradley property, formerly the property of Taggart Paper Company,

Charles Donoghue.

which had owned the dam, to the opposite shore abutting the property of Abe Cooper Watertown Corporation.

The reasons for the dam's original construction no longer existed; it did not serve a useful purpose.

Bradley had signed a "general release" prior to partial removal of the dam. Damage was not contemplated by the New York State Police, who had sought the demolition; army personnel, who were carrying out the mission; or Bradley.

On August 21, 1968, the army blasted a thirty- to forty-five-foot-wide breach in the dam, with the southerly edge of the breach about five to ten feet north of a concrete wall abutting the dam.

State police officers in charge of the detail had no expertise in the use of explosives, and the army personnel had never performed a mission of this nature. Investigator Charles Donoghue testified that he "never heard one of them say they had removed a dam like we were trying to do."

"It was crystal clear that neither the state police nor any other state representatives had discussed the removal of the dam and its possible effects with any hydraulic or marine expert," the judge observed.

In May 1969, the spring runoff of snow water plus heavy rains caused the river to flood. By May 22, downriver flow had peaked at 33,600 cubic feet per second. That flow was "rather exceptional," said Kenneth H. Mayhew, an engineer for the Hudson River–Black River Regulating District. A Bradley official observed that the "water was very high and that it was rough, wild water swirling in and out against the wall, which eventually gave way."

"I noted that when the dam was intact between 1945 and 1969, the property now owned by Bradley was not damaged by the Black River even though on three occasions the peak discharge was over 32,000 cubic feet per second," the judge wrote. "There was no viable proof that this wall was not functional or in a suitable state of repair."

A hydraulic engineer opined that the breach in the dam caused by explosives "deepened the water on the south side of the river and increased the pressure of the water against the wall, causing it to collapse."

Judge Lengyel concurred:

> *It is my opinion…the failure of the wall was a direct result of the breach in the dam which was created at the request of and under the supervision of the New York State Police. I further find that the state police representatives were not versed in what the effect of such a breach might be, and there was*

Epilogue

no proof that the Army demolition engineers were versed in anything other than demolishing barriers.

He continued, "The state police desire and zeal to solve the Egan murders (the guns were never found) outweighed good judgment and caused unqualified personnel to attempt to accomplish a highly technical operation. I find the State negligent."

Bradley was seeking $58,275 in damages, a sum that Judge Lengyel said, "I totally reject." He reasoned that "when the state damages an ordinary structure it does not have to replace it with the Taj Mahal."

He set the award at $9,060 plus interest dating back to May 24, 1969, calculated at $2,890.28, but he also subtracted the $3,000 received in the settlement with Jefferson County, leaving the state's responsibility at $8,950.28.

That court case was the final action stemming from the New Year's Eve 1964 triple execution just outside Watertown. And the criminal investigation is closed. Responding to a crime story on December 29, 1984, in the *Watertown Daily Times*, an investigator with the New York State Police told the newspaper on January 16, 1985, that the murders were solved and the case was closed with the arrest of Joseph Leone, despite his acquittal.

ABOUT THE AUTHORS

Dave Shampine brings to The History Press his fifth offering with this account of the Egan triple homicide of New Year's Eve 1964. This is his first publication since he retired on March 1, 2013, from a nearly forty-two-year career of writing about crime and local history for the *Watertown Daily Times* in New York.

Also to his credit with The History Press are *Remembering New York's North Country: Tales of Times Gone By* (2009); *Colorful Characters of Northern New York: Northern Lights* (2010); *The North Country Murder of Irene Izak: Stained by Her Blood* (2010); and *New York's North Country and the Civil War* (2012).

The lifelong resident of Jefferson County now splits his time between homes outside Watertown and at Lake Helen, Florida.

Mr. Shampine introduces to the publishing world his partner in this story, a man whom he had not met until shortly before publication. And he says he is so impressed by the efforts of Daniel Boyer that he thinks Mr. Boyer should have been a reporter or a private detective.

About the Authors

"His persuasiveness, his ability to cajole sources into expertly conducted interviews and his drive to research until all avenues are exhausted not only impress me but also leave me envious," Mr. Shampine said.

Daniel Thomas Boyer is a Jefferson County native who grew up in Redwood, about thirty miles north of Watertown. He moved south following his graduation from Alexandria Central School in 1976 and eventually settled in Bowling Green, Kentucky, where he continues to reside.

His livelihood was not in writing or research but as a skilled worker for Woodcraft Industries in Bowling Green. After sixteen years, disability forced him into a retirement that gave him the time to research the crime that had haunted him since his youth.

Mr. Boyer, who enjoys playing drums, bass guitar and the harmonica, owns a Facebook site entitled "Where in the Heck Is Redwood, New York." He is a contributor to the Redwood Historical Society.